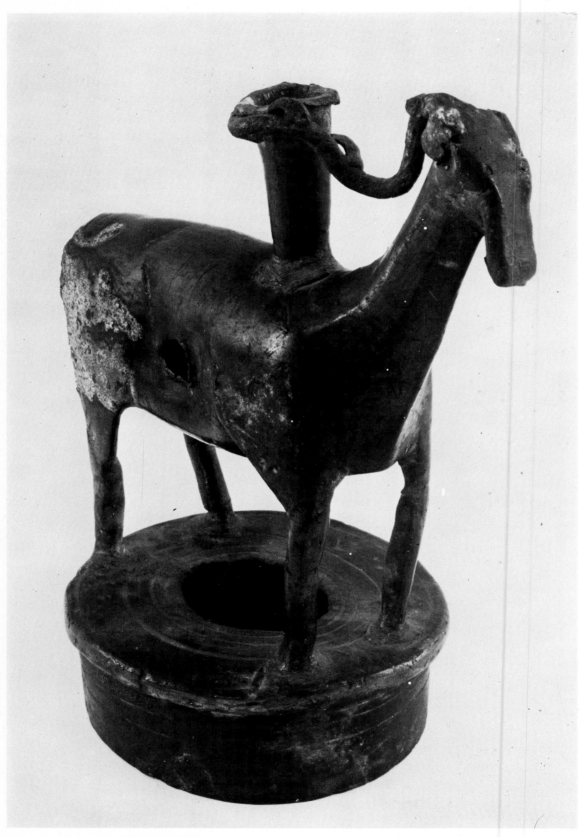

Romano-British pewter animalier socket candlestick excavated in Bath.

Old Domestic Base-Metal
CANDLESTICKS
From the 13th to 19th Century

Produced in
Bronze, Brass, Paktong and Pewter

Ronald F. Michaelis

Antique Collectors' Club

ISBN 0 902028 27 8

British Library CIP Data
Michaelis, Ronald Frederick
 Old domestic base-metal candlesticks from the
 13th-19th century.
 1. Candlesticks — England — History
 I. Title II. Antique Collectors' Club
 739'.5 NK3685

ISBN 0 902028 27 8

Printed in England by Baron Publishing, Church Street, Woodbridge, Suffolk.

Antique Collectors' Club

The Antique Collectors' Club, formed in 1966, pioneered the provision of information on prices for collectors. The Club's magazine *Antique Collecting* was the first to tackle the complex problems of describing to collectors the various features which can influence prices. In response to the enormous demand for this type of information the *Price Guide Series* was introduced in 1968 with **The Price Guide to Antique Furniture,** a book which broke new ground by illustrating the more common types of antique furniture, the sort that collectors could buy in shops and at auctions, rather than the rare museum pieces which had previously been used (and still to a large extent are used) to make up the limited amount of illustrations in books published by commercial publishers. Many other price guides have followed, all copiously illustrated, and greatly appreciated by collectors for the valuable information they contain, quite apart from prices.

Club membership, which is open to all collectors, costs £6.95 per annum. Members receive free of charge *Antique Collecting,* the Club's magazine (published every month except August), which contains well-illustrated articles dealing with the practical aspects of collecting not normally dealt with by magazines. Prices, features of value, investment potential, fakes and forgeries are all given prominence in the magazine.

In addition members buy and sell among themselves; the Club charges a nominal fee for introductions but takes no commission. Since the Club started many thousands of antiques have been offered for sale privately. No other publication contains anything to match the long list of items for sale privately which appears in each issue of the magazine.

The presentation of useful information and the facility to buy and sell privately would alone have assured the success of the Club, but perhaps the feature most valued by members is the ability to make contact with other collectors living nearby. Not only do members learn about the other branches of collecting but they make interesting friendships. The Club organises weekend seminars and other meetings.

As its motto implies, the Club is an amateur organisation designed to help collectors to get the most out of their hobby: it is informal and friendly and gives enormous enjoyment to all concerned.

For Collectors — By Collectors — About Collecting

The Antique Collectors' Club, 5 Church Street, Woodbridge, Suffolk.

Publishers' Preface

Having collected brass candlesticks for some years and being frustrated by the lack of reference literature in this sphere, it was with particular delight that we learnt that the world expert on pewter, Ronald Michaelis, was finalising a book on the subject of base-metal candlesticks. Having met the author, we were deeply impressed, both as collectors and publishers, by his vast knowledge of the subject and we were naturally keen to publish the book when it was ready.

It was while he was finalising the work and adding more photographs at our specific request that the author became ill and, just before he died, entrusted to us the task of producing, editing and publishing this work.

Our main concern has been to ensure that our interpretation of the three drafts, which existed at the author's death, is the interpretation he intended. As far as the illustrative material is concerned, we had already agreed with Ronald Michaelis that the best use possible should be made of his impressive collection of photographs. The collation of several hundred photographs was not easy, but certainly worthwhile, for we feel the large number used is one of the features which makes the book so interesting. Sadly only a small number of footnotes had been completed.

In both respects — text and illustration — we are extremely grateful to Claud Blair, Keeper of the Metalwork Department at the Victoria and Albert Museum, who has read the proofs and made suggestions. Some of his comments are to be found as footnotes, marked by the initials C.B.

The outcome is, we believe, the best book likely to be written on this subject until metalwork dating technology becomes much improved.

Finally, we would like to thank Margaret Michaelis for her patience during the long delay which inevitably resulted in editing this work while running a busy publishing company.

John and Diana Steel
May 1978

Acknowledgements

We are grateful to the following institutions, collections and private collectors who kindly cooperated in making available to Mr. Michaelis photographs for use in this book. In a posthumously published work it will be readily understood that a problem arises in ensuring the acknowledgements are complete. We have endeavoured to make as comprehensive a list as possible, but it may well be that one or two names have been inadvertently excluded. If this is the case we apologise in advance, and if notified will ensure that future prints include the excluded names.

The Barnard Collection
The Boymans Museum, Rotterdam
The British Museum
The Chisenhall Marsh Collection
Messrs. Christie's
The Musée Cluny, Paris
The Colonial Williamsburg Museum, Virginia
The Fripp Collection
The Groves Collection
The Guildhall Museum
Mrs. Margaret Hand
The Historic Churches Preservation Trust
The London Museum
The Minchin Collection
The Mount Edgcumbe family
The Mundey Collection
The National Gallery
The Art Gallery of New South Wales
The Newton Collection
The Rijksmuseum, Amsterdam
The Rollason Collection
The Smith Collection
Messrs. Sotheby's
Captain Spencer-Churchill
The Turner Collection
The Verster Collection
The Victoria and Albert Museum
The Wilders Collection
The Yeates Collection
The Dean and Chapter of York Minster

Contents

Foreword

Most people to whom the name of Ronald F. Michaelis is familiar will undoubtedly think of him in connection with old pewter, on which he was the country's leading authority for over thirty years. This was, however, far from being his only interest, as he was a considerable expert on a number of other antiquarian subjects, among them the history of base-metal candlesticks. Like everyone who has need of information about candlesticks of this kind, he was acutely aware of the lack of any worthwhile general publications about them, apart from Curle's comparatively short article published in 1926, and he long promised that he would himself do something to remedy this deficiency. Many of his friends, myself included, were afraid that his untimely death in 1973 meant the end of all hopes of this work on candlesticks ever appearing, but, fortunately, our fears were unfounded. He had virtually completed the manuscript of his book before he was struck down by his last illness and now, thanks to the interest and enthusiasm of John Steel of the Antique Collectors' Club, it is here published in a manner worthy of its author. Michaelis himself would have been the first to say that it is not the final word on candlesticks, but it does provide the basic text-book on the subject that has been so much needed for such a long time. It is a great pleasure to introduce it to the public.

C. Blair
Keeper
Department of Metalwork
Victoria and Albert Museum

Preface

The justification for any new work should be either, firstly, that it adds something to the information already available on its particular subject, or, secondly, that it casts new light on some otherwise dimly lit project by virtue of the fact that the illumination emanates from an entirely different source.

It is claimed that both these requirements are satisfied in this volume, which is, in fact, the first attempt by any writer in this country to cover the history of candlemaking and candlesticks in sufficiently meticulous detail to warrant its acceptance as a "standard work" in its specific field.

The pedantic reader might be tempted to comment that the new light shed upon domestic candlesticks, for example, does, itself, come from the humble wax or tallow which was the sole basis of illumination in the days of the majority of the specimens described herein — and he would be right! A study of the processes of manufacture of candles themselves, as described by contemporary chandlers and others, leads one to a knowledge of why at different periods in history, the forms of the candlestands, or candle-holders, changed to accommodate them satisfactorily. Forays into the economics of production of wax and tallow respectively have indicated why the first should have been favoured by the church, and the second for domestic purposes — why the church used, principally, the pricket, and the cottager the candle holder with a socket at the top. The ancient records of the Tallow Chandlers' and the Wax Chandlers' Companies have been drawn upon freely in regard to many of the matters to which reference has already been made, and, to a lesser extent, those of the Founders' Company and the Worshipful Company of Pewterers in relation to the manufacture of brass, bronze or pewter, as the case may be, used in the candlesticks themselves.

There has been very little written on candlesticks in the British Isles; the most comprehensive treatise to date, known to the author, is a lengthy and authoritative article by Alexander O. Curle, entitled *Domestic Candlesticks from the 14th to the end of the 18th century*, published in the Proceedings of the Society of Antiquaries of Scotland, Vol. LX, pp. 183—214, in 1926, but this is not easily procurable.

One other writer, the late W.G. Mackay Thomas, followed with a book based on the findings of Mr. Curle, and published it privately; thus it did not reach a very wide circle of readers.

The present writer has had considerable help from Alfred Bonnin's *Tutenag & Paktong*, (1924), a book in which may be found collected references to various alloys of copper and tin, copper and zinc, and other basic materials used by the candlestick maker to produce his wares, whether they be of brass (latten), bronze (bell-metal), paktong or pewter. Percy Macquoid and Ralph Edwards's *Dictionary of English Furniture*, Vol. II., contains a useful chapter on this subject.

One or two foreign publications have been found helpful, but even in Europe the subject does not seem to have been covered comprehensively, and the student must search in a large haystack to find the proverbial needle. In the most unexpected places, and in numerous works not wholly devoted to candlesticks, one may chance on a passing reference or, at best, a page or two, which yields a few crumbs of information on some national types.

A book produced in Norway, *Lys og Lysstell gjennom 1000 Ar.* by Arnstein Berntsen, has been found useful in that it depicts many forms of candlesticks and other lighting devices not elsewhere recorded, and from it, too, has come the record of assays of various qualities of brass and bronze over a wide period of years. Reference must be made, also, to the contributions of Arnold J.G. Verster, the eminent Dutch collector of early bronze, iron and pewter items, which he so well illustrates in his various publications, and to whom my thanks are due for his permission to use photographs of many of his pieces in this work.

In 1970 Hanns-Ulrich Haedeke's *Metalwork* appeared, an exceedingly readable and learned work which should adorn the library shelves of any serious collector of metalwork. He gives considerable space to the constitution of brass and bronze from the earliest times, and refers to candlesticks, in particular, in several periods. Another book entitled *Antique Brass Candlesticks 1450–1750*, printed and published privately by John R. Grove was produced in the U.S.A., in 1967. It is devoted entirely to candlesticks, taper-sticks and rush lights in the author's own collection. Each illustration is accompanied by an explanatory caption, but there is no further text. This has been found useful in that it displays many examples of which illustrations are not available elsewhere, and the present writer is indebted to Mr. Grove for the loan of several photographs acknowledged in the appropriate places.

As our story unfolds it will be seen that the greater proportion of candlesticks produced and used in Europe up to about the middle of the 16th century evolved from a common prototype from the Near East; this fact alone makes it difficult to assign extant specimens to a particular country or origin with any certainty. When to this is added the fact that there was a large export market from several of the manufacturing centres, such as Italy (Venice), Holland, Germany, and perhaps Scandinavian countries, and, of course, England itself, then attribution becomes even more uncertain.

In many cases, particularly with the earlier examples, the writer's source of information has been contemporary oil paintings by European artists. A pictorial record of a certain type of candlestick, in a particular year, does not, necessarily, date it from then; it does, however, establish that the type was then in vogue, or at least known to the artist who

painted it, and so we can say without contradiction that it is *of that date or earlier*. How much earlier, again, is an imponderable factor, for a brass (or bronze) article of this nature could already have served a household for many decades. One fact worthy of mention is that Mr. Curle, who had, himself, examined probably far more primitive paintings than the present writer has been able to do, wrote on this particular point that it was significant that, thus far, *he had not found a single instance of the representation of a candlestick of a type which we now acknowledge to belong to the 14th century in any picture of the 15th or 16th century.* Mr. Curle continued to say that this was all the more surprising in view of the fact that pictures by Renaissance artists, from the middle of the 15th century onwards, and of Dutch artists of the 17th century, showing representations of candlesticks, are by no means uncommon.

The provisional dates ascribed to many of the candlesticks throughout the following pages have been assessed from such reliable sources, combined with a knowledge acquired from the handling of many hundreds of early examples in both private and public collections over a great many years, and, the writer is happy to say, with the benefit of advice from other serious students, exemplified by the late Mr. Harry Willis, whose own superb collection was dispersed only a few years ago, the finest pieces to augment the displays in the London, Guildhall, British and Victoria and Albert Museums (and a few, fortunately, into the writer's collection).

During the last ten years the upsurge of interest in England has brought a large influx of old brass candlesticks from the European Continent, particularly from Spain and Portugal, and those who have brought them to England have believed them to have come from old monasteries, where they have lain hidden in the cellars since they were displaced from the cells of the monks after more modern illumination had been installed. Some of these we have to accept as Spanish types, but many others undoubtedly originated elsewhere, and reached Southern Europe by way of trade from the Netherlands and other centres further North.

The publication of this volume, and the efforts which have gone into it are mere pioneering, and it is to be hoped that, in the course of time, it may stimulate others to divulge the knowledge they, themselves, have accumulated whilst indulging in the study and collection of old candlesticks.

The author's especial thanks are due to Mr. David Walter-Ellis, an appraiser of old domestic metalware with one of London's most important sale-rooms, and to Mr. John Steel, for information on the depiction of early candlesticks in 15th, 16th and 17th century old master paintings, from which many examples have been able to be dated more accurately.

RONALD F. MICHAELIS

1

Candles and Candlemakers

Candles, either of wax or tallow, or a combination of both, for the lighting of churches and domestic dwellings, have been in use for about 2,000 years — possibly even more — but our earliest reliable information of the practice of the chandler in England is around the 10th and 11th centuries A.D.

Formerly, the Romans had a custom of burning candles to the Goddess Februa, mother of Mars, to scare away evil spirits, and this is probably the origin of our own Candlemass Day, which falls on February 2nd.[1]

The candle among the Romans, as with ourselves, was made either of wax (*candela cerea, cereus*) or of tallow (*candela sebacea*); the use of the former being a sign of considerable luxury. We have the evidence of Pliny,[2] who states that the wick of candles in his day was formed of the pith of a kind of rush — the indigenous plant called Scarpus — after the outer casings had been stripped off. They were prepared by repeated dippings in molten wax or tallow until a sufficient quantity had solidified upon them to sustain a flame. It is believed that the Romans introduced candles into Britain, and that, to a great extent, they came to supersede the crude rush lights formerly in use.

From Saxon times onwards we read much of candles but little of rush lights; we have pictorial evidence from contemporary illumined manuscripts as to the use of candles of different sizes, and candlesticks of bone and silver. We have found early reference to *chandlers*. The late R.T. Riley quotes a reference of 1276 in which one Hugh de Rockingham gave a leasehold in St. Clements to Matthew *le chaundeler*, and there are several others of a similar nature, but all mention only *le chaundeler*. Candlewick Street in London is today a perpetuation of the older "Candelwiccestrate", mentioned as early as 1259 as an area populated by the candlemakers.

It is difficult to distinguish between the makers of wax and tallow candles, respectively; according to Mr. R.H. Monier-Williams, a former Clerk to the Worshipful Company of Tallow Chandlers, there is fairly reliable evidence that, where the term "chaundler, chandler or chaundeler" (in these, or in any close variants of their spelling) is used, a *tallow-chandler* is indicated. The earliest known reference to a *wax-chandler*, as such, is under the date 1342, referred to in Dr. Sharpe's Calendar of Wills:- "John de Hynton, wax chandler (*cererarius*), All Hallows, Bread Street".[3] H.T. Riley mentions "William, le cirgier" (which he translates as *wax-chandler*) of 1313.[4]

1 J.C. Thornby and G.W. Hastings, *The Guilds of the City of London,* Wax Chandlers' Company, p.136.
2 Pliny, *Hist. Nat.*, XVI, 178.
3 *The Guilds of the City of London,* op. cit.
4 H.T. Riley, *Memorials of London and London Life,* 1868.

It would seem that, up to about the middle of the 14th century, chandlers probably combined the two trades, but there was growing concern among individuals for separation, and in 1358 the wax-chandlers applied to the Lord Mayor and Aldermen of the City of London for ordinances to govern their particular section of the trade,[1] and in 1371 they petitioned for further powers.[2] The tallow-chandlers were, perhaps, less vociferous at this date, nevertheless they, too, established themselves as a separate branch and, as early as 1393, we read of four "Masters" being chosen for the tallow-chandlers' trade, to survey it.[3]

The relative cost of wax and tallow candles is strikingly shown in entries in the Accounts of the Cofferer to Thomas, Earl of Lancaster (7 Edward II, 1313—4), as follows:-

"for 1714 pounds wax with Vermilion and Turpentine, to make red wax . . . £314.7.4½d." (*Approx. 3/8d. per lb. for the combination of ingredients. R.F.M.*)

"for 1319 pounds of Tallow candles for the household, and 1870 (pounds) of light for Paris-candles called Perches[4] . . £31.14.3d." (*Less than 2½d. per lb. R.F.M.*)

Things were very little better in the following century, as may be judged by the fact that in 1433 an Act (II Henry VI, Cap. 12) was passed which stated that "the wax-chandlers in divers parts of England sell candles, images and figures, and other works of wax made for offerings, at the rate of ijs. and more the pound . . . whereas one lb. of wax so wrought is worth no more than vjd." This Act enjoined them to add iijd. only per pound over and above the cost of a pound of plain wax. Strype found the following (he says, in his edition of Stow's *Survey of London*) in the Book of Henry Brooke, Esq., Clerk of the Market (Leadenhall) of our Sovereign Lord, King Henry IVth, under the date 1468:-

". . . for when a tallow-chandler bieth a pound of Tallowe for an Halfpenny he shall sell a pounde of candell for a Peny; that is, a Ferthyng for the Wyke (wick) and wast (waste) and another Ferthyng for the workmanshyppe".

Thus one can see that, in the mid-15th century, wax candles, although being charged at the rate of 2/-d and more the pound, could have been sold at about 6d. the pound, whereas the tallow-chandlers were enjoined to charge no more than 1d. per lb. for their wares. Why there should have been such a discrepancy in the prices for workmanship is an inexplicable factor. Nevertheless, with such a great disparity in prices for the two commodities it is not surprising that the cottagers preferred to use tallow (and thus a hollow-socketed candleholder to sustain the softer, more messy and easily meltable tallow dip), whereas the church, with its greater resources, could afford the harder wax product (for which the pricket holder was more suitable). Yet another reason for the use of wax candles for ecclesiastical purposes is put forward by the compiler of notes in relation to the Wax Chandlers Company, to wit, "wax candles were preferred for religious use, and especially for the Altar, because of an ancient notion that bees, in the first instance, came direct from Paradise".[5]

There are numerous confirmatory references to wax for candles in

1 H.T. Riley, *Memorials of London and London Life*, 1868, fol. xcii., pp.300-302.
2 H.T. Riley, op. cit., fol. xclxxxiii., p.358 *et. seq.*
3 H.T. Riley, op. cit., Letter Book "H".
4 Note that at this date (1313) "Perches" (candles for placing on "perks" or spikes of metal, otherwise prickets) were being made of tallow, whereas in 1358 the wax chandlers were ordered to make theirs "of fine unadulterated wax."
5 *The Guilds of the City of London*, op. cit., p.136.

church use; one in particular is of interest in that it appears in the Will of one John Bracy, a "talugh chanadler" of 1470, in which he bequeaths, *inter alia*, a sum "for *wax candles* to burn round my tomb". In one of the earliest documents in possession of the Tallow-Chandlers Company (1519), there are the items:- "Paid to the Wax-chandler for the light at St. Botolph's, vijd."; "Paid for wax at the Sowle Mas, iiijd.".

Fats for the making of tallow for the softer candles used domestically were readily available from the slaughter-houses in virtually all country districts, but to cater for the rapidly growing commercial market in candles, and also for the Sopers (or Soap makers), the other main users of this commodity, large quantities of tallow were imported; we learn that, in later years, Russia supplied prodigious quantities.

In the late 15th century, and for many decades thereafter, Venice was the chief source of supply, not only of wax candles, but of untreated wax, to the rest of Europe, and the value of this imported commodity to England, through the Port of London, between the years 1479 and 1483 alone exceeded £11,000.[1]

It was, to a great extent, traffic between the Far East and Venice, in the first instance, and Venice with the rest of the western world, that was responsible for the importation and eventual adoption of both Eastern and Venetian features in candle-holders themselves, of which more will be written in later chapters.

The resurrection of the rush light in the mid-18th century may, to some extent, explain why, in this period, brass and other base-metal candlesticks seem to have been rather less used than either formerly or later. Those who could afford silver candlesticks could afford wax candles, those who could not afford even tallow candles could, at least, patronize the local blacksmith for an iron rush light holder!

The imposition of the Candle Tax in 1709 forbade the making and use of home-made candles, and all complements connected with their making were hidden or destroyed.

The names for some candles are shown in the Ordinances of the Wax Chandlers (dated 24th June 1358)[2] in which it is stated that certain types "known as 'cierges', 'torchys', 'priketz, and 'great candles' were to be made of pure unadulterated wax", and even the standard of the wicks was controlled — these should not be heavier than necessary for the size of the candle supplied; "neither should they contain any fat, 'code' (cobblers' wax), resin or other impurities".

Another name to which references will occasionally be found, especially in relation to funerals, or to "lying in state", and suchlike obsequities, is a "Mortex" or "Mortar"; "Mortars (de Mortariis)" are, as H.T. Riley explains, "a kind of wax candle, so called from being used at funeral obsequies or mortuaries". Mortars were, however, not necessarily made of wax — the word relates to a *shape or size* in candles, and has been used as a synonym of "night-light".[3]

It has been said that the Romans, with their more advanced candles (and, of course, their oil lamps) caused the rush lights of the early Britons to become redundant, and there is little in later written history to indicate that the rush light had any great following again until the middle of the 18th century, when, no doubt as a result of the high cost

1 Mackay Thomas, *Candlesticks from 1500.*
2 H.T. Riley, op. cit., fol. xcii.
3 M.F. Monier Williams, *Records of the Worshipful Company of Tallow Chandlers*, Vol. II, London, 1895.

of candles, it became a necessary economy for the housewife to produce her own utility illumination in the form of dipped rushes. That observant chronicler of rural life, Gilbert White, of Selborne, said in 1776:-

"... the matter alluded to is the use of rushes instead of candles, which I am well aware prevails in many districts besides this (Selborne, Dorset). But as I know there are countries (?counties) also where it does not obtain ... I shall proceed in my humble story ...

"The proper species of rush for this purpose seems to be the *juncus conglomeratus*, or common soft rush, which is to be found in moist soft pastures by the side of streams and under hedges. These rushes are in the best condition in the height of summer, as soon as they are cut they must be flung into the water and left there; for otherwise they will dry and shrink and the peel will not run."

He goes on to say that the damp rush must then be divested of its peel so as to produce a series of regular narrow strips from top to bottom with pith still adhering to them, these strips to be left out on the dewy grass for several nights and then sun-dried. Fat is scalded and the strips of rush are dipped in it; the scummings of the bacon-pot are used after allowing the salt to settle. Six pounds of grease will dip a pound of rushes. If a little beeswax or mutton suet is added this will give a stiffer consistency for longer burning and render it more cleanly to handle.

For rush dips of this nature a device quite different from a socket candleholder was needed to support them. A few examples of these wrought iron objects will be illustrated in later pages.

Some of them were provided with candle sockets in addition to the scissors-like fingers; no doubt for those households where they were able, perhaps, to roll their own candles.

Specimens of all the above are now avidly collected and, in consequence, are attracting quite high prices in the collectors' market, but they do not unduly concern us here.

The most lucid account of candle-making which has come to the notice of the present writer is that from the *Cyclopaedia of the Useful Arts*, published by George Virtue shortly after the Great Exhibition of 1851. It commences with the statement that the chief ingredient used in the making of candles is tallow.

This substance is the concrete fat of oxen, deer, sheep and other large quadrupeds. The supply is made up by home-slaughter and by importation, chiefly from Russia (which supplies about 60,000 or 70,000 tons yearly). Other large quantities come from Australia and the Rio de la Plata.

The *Cyclopaedia* further states that "... ordinary candles are made of tallow and are *either dipped or moulded*. Mutton suet with a proportion of ox-tallow is used for mould candles which are required to be hard and to have a glossy surface. Coarse tallow is used for dips". The wicks used for the best candles are cotton rovings (i.e. coarse cords) imported from Turkey. Four or more skeins, according to the thickness of the wick required, are wound off one at a time into "bottoms" or "clues", and afterwards cut to the proper lengths, first being doubled and twisted so as to leave a loop at one end.

Wicks for "dip candles" (i.e. those made from coarse tallow) are made in long lengths and are laid out in a regular loop pattern, with a rod (or "broach") threaded through the top loops; a knife is then drawn across the bottom of the threads which ensures all wicks are the same length. They are then dipped lightly in molten tallow and rolled between the hands to twist the wicks. A series of these broaches, with their pendant wicks, is set into a frame and placed on a beam suspended over the vat of hot tallow, and a balanced arm allows them to be dipped as often as necessary. The wicks are dipped three times for the first lay, and the beam is then swung over to a position over a cool pan to allow the dips to drain and harden. This process of dipping and hardening is repeated a second or third time as necessary to attain the requisite weight of candle.

Moulded Tallow Candles

The moulds used in making cast candles are more frequently of pewter, although both brass and copper are sometimes used, and are of two parts; namely, a hollow cylinder of the size of the candle, open at both ends, and polished on the inside, and a small conical metallic cap with a hole in the centre for the wick. These moulds, with cap affixed, are set up in batteries of eight or twelve in a wooden frame; the upper part of which is a shallow trough with the open ends of the moulds level with the surface. A length of wick is then inserted through the cap of the first mould and up through its length. It is then trailed down and through the second mould, and so on until the battery is completed. A wire rod is placed through the projecting loop of each wick, and is fixed and drawn tight, so that the wick may be centralized along the axis of the cylinder. The moulds are gradually filled by running molten tallow into the trough; when the moulds are about half full a workman pulls the short end of wick which projects from the cap to ensure it is tight, and the pouring continues until all moulds are full. The frame of moulds is then put aside to cool and set until the following day. When hardened, the candles are pulled out of the moulds by the top loops, which are then cut off and the broad ends of the candles scraped flat. Candles are then removed to a cool warehouse, where they are stored for several months, during which time they become sufficiently white for sale.

Wax Candles

Wax is not adapted for moulding owing to its tendencies to adhere to the mould and to contract on cooling. Wax candles are made in the following manner: a set of wicks, properly cut to lengths, twisted and warmed, are attached to a ring of wood or metal, and suspended over a vat of molten wax which is then taken up by a ladle and poured on the tops of the wicks, each wick being kept constantly twisted round its axis by the fingers; the wax, in running down, adheres to the wicks and completely covers them. This process is repeated at intervals until a sufficient thickness is achieved. The candles are then rolled, whilst still hot, with a flat surface of box-wood upon a smooth table of walnut wood, kept constantly wet; this makes them truly cylindrical.

The large candles used in Roman Catholic churches were made by placing a wick upon a thick slab of wax whilst still in pliable state, and

then folding this round the wick and rolling it in the manner already described above.

These, broadly, were the older fashions of candle-making, and the recording of the processes involved helps one to an understanding of why, at various times, the types of candle-holders varied, i.e. why, at one period, a large drip catcher was incorporated, and why, at others, this could be reduced and, later still, dispensed with entirely. An early example of this occurs on February 8th, 1639, when a group of individuals, Mathias Burges, Thomas Barber and Smith Wilkinson patented "a new waie and means for making candells, taps (tapers), links and torches, chiefly with foraine commodities, as oyls not formerly used in candells".[1] It was improvements such as this, and others spread over the next hundred years or so, that led eventually to the continuous taper-holder and to devices of the nature of "Crampton's Patent" and Palmers' "Metallic Wick" candle-holder with which our story ends.

1 B. Woodcroft, *Abridgments of specifications relating to Oils, Fats, Lubricants, Candles and Soap, AD 1617-1866, ptd. for the Commissions of Patents, 1873.*

2

On Metals, and Methods of Manufacture

Candlesticks over the centuries have been made in a very large variety of metals and alloys, including iron, bronze, brass, pewter and silver. Bone, wood, glass, earthenware and enamelled metals have also been used, but it is only with those in the baser metals with which this particular study is involved. Silver has been excluded simply because early specimens of date prior to about the end of the 16th century, although known to have been made and used, especially in the churches, are now practically non-existent. Other silver examples, of later date, are so expensive that they have virtually priced themselves out of range of the average collector. Nevertheless, when considering the periods and provenances of some later types in base metal the knowledge derived from marked silver specimens has been used extensively. Similarly, in a few rare instances, Continental pewter examples which show a datable pewterer's mark have also been resorted to for information they can throw on the longevity of use of particular forms.

In the main, the specimens available to collectors have been of iron, bronze and brass, and some of these will be shown to date from as early as the 13th century. Iron would have been the mineral most likely to have been used for early Roman candlesticks, but due to the fact that specimens would, in all probability, have disintegrated in the fifteen or sixteen centuries of their burial, examples are just not available. Nevertheless, an iron specimen[1] — undoubtedly early — was found in the river Witham, near Kirkstead Abbey, to which has been given a doubtful Roman attribution; this particular piece (figure 1) displays both pricket and socket candle-holders, set upon a tray base, which itself stands upon three bent iron legs, riveted into position. Another, with three prickets,

Figure 1.

1 Illustrated in J. Starkie Gardner's *Ironwork*, Part I, V and A, 1914, pp.54-55.

copied here from a photograph in Verster's *Ijzer van vroeger* (figure 2) is similarly doubtfully accredited to a Romanesque source — both of these, in the humble opinion of the present writer, should be given a date several centuries later.

One example, which there can be no doubt is of Romano-British origin, is the superb pewter animalier socket candlestick shown in our frontispiece.

The earliest written records of candlesticks in Britain known to the present chronicler are those for church purposes referred to in the lists of official Visitations to Devonshire churches between the years 1301 and 1330,[1] where, for example, we find (at Dawlish, 5th July, 1301) "Two very beautiful processional candlesticks, and four of pewter"; and (at Colyton, 10th July, 1301) "Two small candlesticks of pewter for procession". Numerous records of candlesticks as domestic necessities exist in wills and inventories; to wit, in 1556, the inventory of household goods, etc., of Sir John Gage, of West Firle in the County of Sussex,[2] includes reference to:-

"v. flate lowe candlestickes of pewter with ij noses the pece.

"ij highe·candlestickes of pewter.

"iiij greate bell candlestickes for preachers.

"ij bell candlestickes for preachers, of a lesser sort.

"iij brode candlestickes used daily in the parlour.

"ij highe candlestickes, of another makying, for the lyvery".

Again in 1562, the inventory of goods of John Wycliffe, a yeoman of Richmond, Yorkshire, mentions three specific types, viz:-

"six Flanders candelstyckes, vjs.

"iii beld candelstyckes and ij flower'd candelstyckes vjs."

Flanders candlesticks at 1s. each are entered in many other Elizabethan inventories.

The first mention of candlesticks in the records of the Worshipful Company of Pewterers is in the ordinances of 1348; they are again briefly mentioned in 1562—3, but it is not until 1612—13 that any specific details are given by which existing types might be recognised. In that year a quantity of "tryffles" (a term designating the quality of

Figure 2.

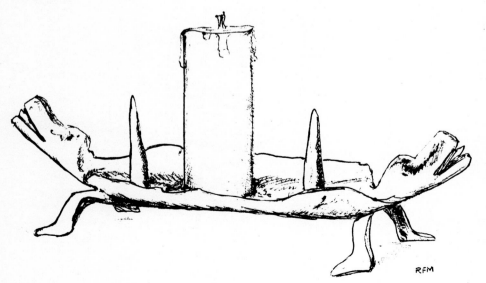

1 H. Michael Whitley, Trans. Devon-shire Assn., Vol. XLII, July 1910.
2 R. Garraway Rue, F.S.A., Sussex Arch. Soc. Coll., Vol. XLV, 1902.

metal from which certain items, including candlesticks, were made) were assayed by the Company, and standards of weight for each type and size were laid down; the following list is as quoted, with the weights applying, in all cases, *to pairs:—*[1]

Ould fashion	Ordinarie high c'sticks, to weigh, per pr. 3¼ lbs.
Candlesticks	Greate middel, to weigh, per pair, 2 lbs. 2 ozs.
	Greate pyllar, to weigh, per pair, 3 lbs.
	Smale middel, to weigh, per pair, 2¼ lbs.
	Middle pyller, to weigh, per pair, 2½ lbs.
Geo. Smythe	Smale fashion, to weigh, per pair, 2½ lbs.
(thought to	Greate New fashion, to weigh, per pr. 3 lbs.
indicate the	Greate bell, to weigh, per pair, 3½ lbs.
name of a maker	Low bell, to weigh, per pair, 3½ lbs.
of this particular	Greate Wryteinge, to weigh, per pair, 1½ lbs.
form.)	Midd. Wryteinge, to weigh, per pair, 1 lb.
	Smale Wryteinge, to weigh, per pair, ¾ lb.
Candlesticks	Graund, to weigh, per pair, 4½ lbs.
with	Ordinarie highe, to weigh, per pair, 3¼ lbs.
bawles.	Greate Middle, to weigh, per pair, 2 lbs. 2 ozs.
	Small Middle, to weigh, per pair, 2¼ lbs.
	Greate Wryteinge, to weigh, per pair, 1½ lbs.

Candlesticks of this early period, in pewter, are extremely rare, but not so in brass or bronze, although (as all collectors will know) specimens are not too easy to come by.

According to Bonnin, brass consists of copper two parts and zinc one part for "fine brass", and varies to copper four parts, zinc one part for "tough brass". Brass, (as distinct from bronze) was certainly known to the early Romans, for a coin of 20 B.C., was found, upon analysis, to contain 17.3% of zinc; such an alloy was known to Pliny by the name *aurichalcum*. The monumental brass of Sir John Dauberon, at Stoke d'Abernon (c.1277) was found to contain 66% copper, 1% — 3% tin, about 7% lead and the remainder (about 25%) of zinc. It is obvious that one could never lay down a hard and fast rule as to what should be the constituents of brass, but it is certain that, if zinc is present to any appreciable extent — in preponderance to, or to the exclusion of, tin — then it is not bronze as we understand it today.

Zinc was not known as a separate metal in Europe until about the beginning of the 16th century, and any zinc which appeared in earlier brass was produced by melting copper with a zinc-bearing ore known as calamine (carbonate of zinc). In fact, metallic zinc was not produced on a large enough scale for general commerical purposes until well into the 18th century.

In 1565 Queen Elizabeth I granted a patent to William Humfrey and Christopher Schutz, (a German mining engineer), for the exclusive rights of working calamine and making brass, and confirmed this by a Royal Charter in 1568.[2] In the following year another German merchant, Daniel Hochstetter, whose mining interests in the Tyrol were considered to be among the most important in Europe, was brought to this country, and it is he who is known to have been responsible for the setting up of the Mines Royal Company. In 1568 he amalgamated his interests with those of Humfrey and Schutz, and a body was formed, known as "The

1 C. Welch, History of the Worshipful Company of Pewterers, Vol. II, p.62.
2 *Ency. Brit.* (brass).

Governors, Assistants and Societies of the City of London, of and for the Mineral and Battery Works", which continued to exercise its functions down to the year 1710.

The word "Battery" refers to the process of hammering brass into sheets, but by the latter half of the 18th century other methods were adopted, such as the rolling mill.

In 1568 or thereabouts English brass was made to a formula of 40 lbs. copper and 60 lbs. calamine; this produced 60 lbs. of brass (a little salt and alum was included).[1]

In 1582 the privileges given to the battery works were leased, for a term of fourteen years, to John Brode and three partners.

English brass was not made in commercial quantities until after about 1585, even then, and for the next hundred years, only comparatively limited quantities were produced — brass-workers would not tolerate its poor qualities; thus, it was still necessary to import ingots from Holland and Germany. These ingots were of a somewhat softer metal, and finer in colour. Domestic ware cast from the early English brass was found to be highly vesicular, as melted copper absorbs gases, and large quantities of bubbles remained in the metal, resulting in a "spongy" casting, with the surface marred by slight pitting. Although the surfaces were later trimmed by foot-operated lathes, there frequently remained pitted areas or spots.

In some cases where an otherwise good casting had suffered by a particularly ugly scar, that section was cut out and the aperture filled with a new segment of metal; this was then hammered all over to ensure a tight fit. The normal lathe-turning which was part of the finishing process practically eliminated all traces of the repair, but examples may occasionally be found in which, during the long period since the operation, the segment has shifted slightly and thus enables the insertion to be seen, or perhaps it has become visible due to a slightly different alloy having been used in the patch, which has thereby become apparent under oxidation.

By its very nature calamine brass was hard and brittle, and the blemishes which were allowed to remain often weakened the casting to allow cracks to appear, or for portions of the base or sconce actually to break away. All these features are useful pointers to age.

Castings of early date were made in crude moulds of either sand or clay, and undoubtedly would leave the mould with coarse granular patterned markings over the whole surface. The outer surfaces were normally carefully finished and trimmed before the article left the workshop, but in some of the earliest no effort was made to trim the uneven underside, and on occasions it may be found that a small particle of sand, which had become embedded in the candlestick metal remains visible (in some cases, even on the trimmed surface).

It is not possible to assign any particular date or period to candlesticks with untrimmed bases, for although it had become a frequent practice to trim all surfaces, including the underside, by the end of the 15th century, many foot shapes did not lend themselves readily to such treatment on the unsophisticated polishing wheels then available. It is therefore unsafe to place too much reliance on one or the other of these features alone, but to assess the age from other characteristics.

1 *Ency. Brit.*, op. cit.

In 1690 (the monopolies having ended in the previous year) two men, John Duckett and Gabriel Wayne, invented furnaces capable of producing increased heat, and improvements were also made in brass-casting processes. The new brass produced at this time was made more malleable, and of a lighter shade, by the addition of about 7lbs. lead to each hundredweight of brass, but the surface still showed blemishes. The proportions of copper and calamine (or copper and zinc) still varied somewhat between one manufacturing centre and another, and no really stabilized formula seems to have been adopted until 1780 or 1781, when one James Emerson secured a patent for a new brass, of two parts of copper to one of zinc, described (by R. Watson, in his "Chemical Essays", 1786) as "being more malleable, beautiful, and of a colour more resembling gold than brass made with calamine".[1]

The surface of this brass was rarely blemished by pitting — this is virtually the same alloy used today for good quality wares. Bronze is an alloy of copper and tin, and, again according to Bonnin, does not contain zinc (but see Appendix for analysis chart).

The colour may vary from a deep coppery colour, through pale copper tints to almost pure "white". The proportions of copper and tin vary at different times and as constituted by different makers, but roughly in proportions of about four parts of copper to one of tin, producing a blend of metal with a good resonance; it is this quality which has become known as "bell-metal", for obvious reasons.

"Gun-metal" takes its name from the metal from which cannon were customarily made. There was no fixed formula for it, and it may be regarded as identical with what is now termed bronze, that is, roughly, copper nine parts and tin one. Articles described as "gun-metal" should, strictly speaking, have been made from old and disused cannon melted down for the purpose. Alfred Bonnin quotes a reference of 1751 which is interesting enough to be repeated here, to wit:-

"To make the mixture fit for great guns, mortars and other pieces of artillery, the best and softest tin of Cornwall is a necessity, skilfully applied.

"There must be 6, 7 or 8 pounds of it to 100 weight of red copper, more or less, according as this last metal happens to be of better or worse quality".

Latten is a corruption of the French word *laiton*. References to latten in historical records relate, probably to the copper-tin alloy in the proportions of approx. 66% copper to the balance of tin and zinc combined,[2] or was applied indiscriminately to almost any yellowish alloy of copper and white metal; in later years, however, it came to be used to designate true brass (i.e. copper and calamine, or copper and zinc), and should be looked upon today as merely a synonym for brass.

So far as is known there have been no comprehensive analyses made of brass and bronze candlesticks in England, and it may well be that such an exercise would not produce any really helpful data in proving provenance, or age, because of the vast imports of foreign brasses which have been used here in combination with locally produced alloys.

We have become accustomed to classifying particular specimens as "brass" or "bronze", "bell-metal" or "gun-metal" according to colour or tint of the metal, but this has been found to be totally unreliable in the

1 Alfred Bonnin, *Paktong and Tutenag.*
2 The most recent technical study of the composition of brass, latten, etc. gives a different proportion, H.K. Cameron, *Technical Aspects of Medieval Monumental Brasses,* **The Archaeological Journal** 131 (1974), pp.215 ff. C.B.

extensive tests undertaken in Norway. Arnstein Berntsen refers to the analyses of selected specimens from the Viking period (i.e. pre-Norman), A.D. 500-1050, through to the middle of the 19th century, and his illustrated chart makes an interesting study. It will be found in the Appendix at the end of this volume.

It will be seen that there is a fraction of between 1% and 2% of lead in all the specimens of all periods; that zinc is present in all to a greater or lesser degree, ranging from 5% to 25% where tin is also present, and from 17% to 39% where the alloy is tin-free; this latter is the hard brass which is virtually the same as that in use today for cheap commercial brassware.

We have seen that, in England, prior to the mid-16th century, little of the alloy brass was produced locally, and that our brass-workers had to rely, principally, on imported made-up brassware, or on whatever scrap-metal they could reconstitute. This was not the case with bronze, however, for the two basic ingredients had always been available in this country in profusion. Both copper and tin, in fact, in some cases, were found in the same mine workings in Cornwall or Devon, but at different depths.

Thus it is that candlesticks made in England, of a period prior to 1560, are more likely to have been made in bronze, of any one of a variety of tints, but distinguishable from brass. Similarly, candlesticks of a good quality pale yellow "brassy" metal are *less likely* to be of English origin; if such have been found here in excavations, and are believed, by other reasonable factors, to be of early period, it would be wiser to assume them to be importations from abroad, rather than home products.

Tin was not mined to any considerable extent on the Continent, and what was used there for the making of bronze and pewter during the years which concern us here, would have been exported from England, and thus it is unlikely that it would have been used by Continental braziers in articles to be re-exported. The foreign pewterers were the prime users of tin, and even they had to add considerable quantities of lead to it to make it go round.

Candlesticks of brass, displaying blemishes resulting from the earlier experiments in brass casting, also are more likely to be of English origin than otherwise, for we know that the imported brass was of far superior quality, and of better colour. Nevertheless, we know also that large quantities of brassware - candlesticks included - were made here from this imported brass, and so attribution on these facts alone must necessarily be somewhat unreliable. The above pointers should be used as guides only, in conjunction with whatever other information is available on the particular candlestick under consideration.

A feature which is constant on practically all candle-holders up to the last quarter of the 16th century, with only rare exceptions, is a solid metal stem; only the underside of the foot is hollow, and this has been achieved by the simple process of inserting a suitably shaped core, or "plug" in the mould (a similar method was adopted to produce the hollow candle socket of other types).

From the early 17th century onwards brass, bronze *and* pewter candlesticks become more prolific, and national types begin to emerge more strongly, which makes the task of attribution less hazardous.

3

Pricket Candle-holders

There would seem to be little doubt that the first means of artificial lighting would have been by oil lamp; the very earliest, probably, no more than a depression in a stone into which oil or fat was poured, and perhaps into which some moss or tangled dried vegetable matter was introduced.

It cannot have been a big step towards some other device which would not only be safer than the open stone mould, but which would burn for a longer period, and with a brighter glow. More solid fats — beeswax, animal suet and lard — could so easily be rolled into suitable shapes and a wick of rush added that one must, I think, credit the primitives who first produced fire with intelligence enough to have devised some improvements of this nature, even perhaps, before the oil lamp itself. It is logical to assume that the first primitive "candle" would need support, either in the form of a spike upon which the fatty substance could be impaled, or a cup-shaped depression into which it could be lodged — hence the so-called pricket candle-holder and the "candle socket" respectively. It again seems logical to assume that the pricket might have been the forerunner, for, in its earlier form, it was probably no more than a simple pointed bar of iron stuck into the ground, or projecting from a crude wooden base, or perhaps an angled arm with points at both ends, one to be inserted in the wall and the other upon which to place the candle.

In churches it was not unusual to find "candle beams", in the form of two crossed irons or timbers, with several spikes, or "prickets" set along the beams at intervals.[1] For domestic use, where less light was required, a single pricket would suffice.

In cottages and smaller homes wall lighting would not have been a common feature, but where used at all, the most likely fitting for the purpose would have been something like that already described, but most probably with the extension finished off with a drip-pan beneath the pricket. Others, also of wrought iron, would hang upon a nail in the wall and could be taken down and carried to another part of the house; many of these early devices are illustrated and described in Seymour Lindsey's book. Arnstein Bernsten describes a form of hanging loop of iron, with a pricket and cup set in the lower circumference of the circle, which has been known from Viking times.

1 Lys og Lysstell, Oslo 1965.

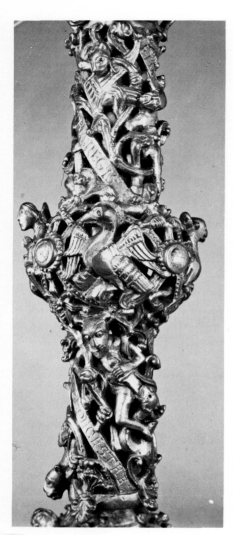

Figure 3 (detail).

The first of the more decorative portable candle-holders were undoubtedly made for ecclesiastical purposes, either for ordinary illumination or for some particular ceremony, and their use as a household appliance did not come under notice until the middle ages.

Candlesticks of pricket type have been referred to in ancient records from about the 12th century, and a few very early specimens from about this period have been excavated both in England and on the Continent. Some of these, from both private and museum collections, will be described here, but it seems that no really national types emerge, nor could one say which, if any, was made for purely domestic purposes. It would seem practicable to take size as a guide, and to assume that the smaller examples, of no more than, say 15 inches in height overall to the top of the pricket spike, were the more suitable (and therefore the more likely to be) for domestic use, and that the taller and more elaborately ornamented specimens were made for ecclesiastical purposes.

Very few really early examples, of any size, which can be attributed with certainty to the pre-14th century are known to exist, but one notable specimen is, of course, the famous Gloucester candlestick, now in the Victoria & Albert Museum, (figure 3). Although it cannot be called a domestic piece by any stretch of imagination, it is of such importance as a datable object — and, thus, a "key piece" — that details are given here in the hope that, perhaps, certain features will assist in the classification of others. It is believed to have been the work of English craftsmen, and was cast in three sections by the *cire perdu*, or "lost wax" process. The definition of the intricate ornamentation is so fine that it required practically no trimming up with tools after its removal from the sectional moulds which would have been required for its manufacture.

It has had a chequered history; a riband entwining the stem bears the following inscription, in Latin:

ABBATIS : PETRI : GREGIS ET DEVOTIO : MITIS : ME : DEDIT : ECCESIE : SCI : PETRI : GLOECESTRE. (The devotion of Abbot Peter and his gentle flock gave me to the Church of St. Peter at Gloucester.)

The Abbot mentioned here was elected head of the Benedictine Monastery of St. Peter on the 9th August, 1104, and he died in 1111. After the destruction of the monastery around 1122, records of its peregrinations are obscure, but it seems to have passed into private hands, and shortly afterwards it was presented to the Cathedral of Le Mans, in France, by one Thomas de Poché. This is recorded in an inscription in 13th century characters around the grease-pan. The candlestick disappeared from the Cathedral during the French Revolution, and again came into private hands until 1861, when it was eventually purchased for the nation by the authorities of the Victoria and Albert Museum, in whose possession it now remains.[1] The metal from which it was cast is a high quality coppery bronze, heavily gilded.[2] The candlestick is approximately 20 inches in height to the top of the grease-pan, and as one might expect, is of pricket type, made to take a candle of about 4 inches in diameter.

Other tall pricket-sticks, some apparently dating from the 14th century, are extant, but these, too, will, in all probability, have been

1 Charles Oman, *The Gloucester Candlestick*, HMSO, 1958 (V & A).
2 The candlestick was analysed for the first time in 1977. It is, in fact, bronze with a very high silver content. C.B.

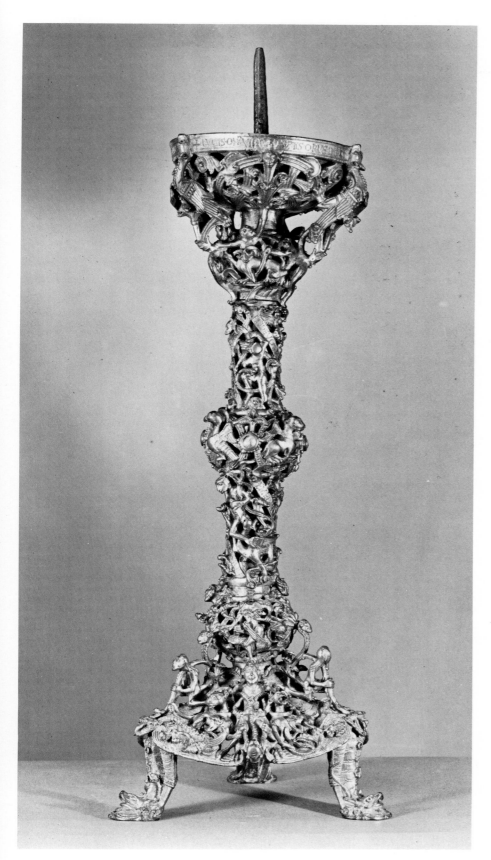

Figure 3.

made for ecclesiastical use, but their specific usage is more difficult to define with certainty, for there is no doubt that gradually the same designs and types were adopted for domestic purposes.

The Gloucester candlestick has a flared three-flanged base, set upon three decorated feet in the form of dragons' heads, the body and wings forming the wide base, and whilst these feet are far more ornamental than those normally employed, the principle persisted, and it is more common to find the feet on very early types designed as claws, hooves, or animals' paws. The specimen at Fig. 4 is probably one of the earliest bronze specimens of a tripod pricket in existence, and is in pale tinctured bronze; it appears to have been cast in one piece by the use of intricate sectional moulds. It has, however, a multiplicity of features which one does not find on the majority of known specimens, to wit the broad triple-flanged base above the paw feet; each flange is divided by a ridge down the middle, which has the effect of slightly cupping the areas on either side. The column is of solid baluster formation, with a well-defined 'teardrop' knop in the centre. The drip-pan (see figure 4 below, left) is its most unusual feature, for whereas the pan on most specimens is of true saucer-shape, with the underside following the same outline as the cupped internal depression the drip catcher on this specimen is cupped on the upper surface from which rises the pricket and it also has a hollow, concave curve on the underside; a sectional cut through the drip-pan would show it to be of the shape drawn here.

The pricket upon which the candle would sit is also unusual, inasmuch as it has been cast as a true, and unilateral, cylinder throughout from the pan up; the point being achieved later by filing or grinding away four flat, triangular, facets, which meet at the apex.

This particular pricket holder is undoubtedly of very ancient make and only two others of comparable form, both in bronze, are known to this writer. One is in the British Museum, where it is catalogued as "Coptic of the 4th-5th century", the other (figure 5) was illustrated in the sale catalogue of a well-known London sale-room in 1961 and stated to be Coptic of the 5th-6th century.

Beneath the wide base flanges of figure 4 may be seen some crude markings, in relief, which evidently result from scratched incisions in the mould itself. These, so far as they may be identified are reproduced here.

Figure 4 (section).

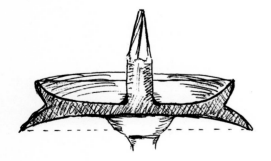

Figure 4 (detail).

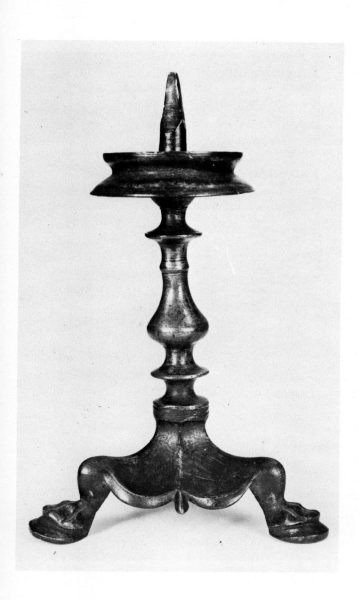

Figure 4.

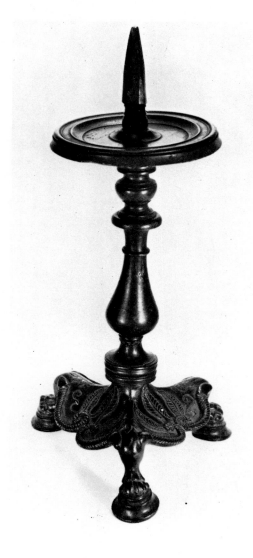

Figure 5.

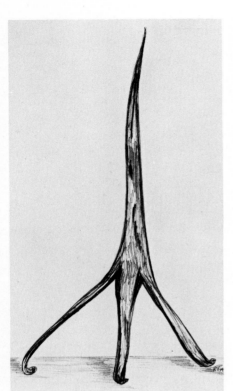

Figure 6.

The earliest of all domestic prickets were made with a simple tripod base, somewhat on the lines of the iron specimen shown here (figure 6). This particular item is in the possession of the Guildhall Museum, in London, and is entered in their catalogue as of the 16th century. It is 6 inches high. No doubt this attribution of date has been given because of the context in which it was found, but one cannot preclude the possibility that it is much older; had it, in fact, come to the writer's notice without supporting evidence it would, on type alone, have been placed several centuries earlier. Accepting this, therefore, as merely a provincial blacksmith's adaptation of what has now come to be accepted as the basic 13th century form we can trace the evolution from this simple pricket spike through a succession of early examples in the following illustrations.

Figure 7 shows a brass or bronze candlestick in the Musée Cluny, Paris, with features showing clearly the next stage in development. The slim tripod base is maintained, and so is the tapered stem (which might, just as readily, have terminated with a pricket spike); the addition is the drip-tray, which, in one form or another accompanies our succeeding examples.

The bronze pricket-holder with fretted ornamental tripod base (figure 8), and the plainer specimen (figure 9) may be placed closely in period with the Gloucester pricket, and, indeed, show several similar

Figure 7.

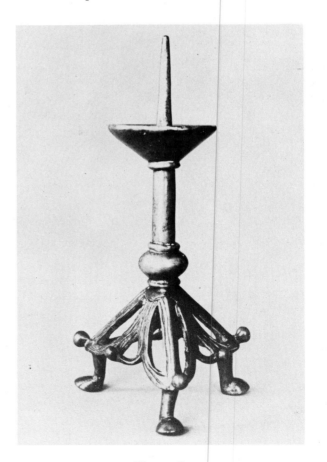

Figure 8.

characteristics. A feature to note in the second of these examples is the incidence of small projections around the edge of the grease-pan; they appear again in fine enamelled bronze candlesticks of the same form from Limoges (figures 9a and 9b in the British Museum and the Victoria and Albert respectively). There is no logical explanation for their adoption, and they are doubtless purely ornamental, nevertheless they appear to be confined to a few only of the 13th to 15th century candlesticks, all of pricket type.

That in figure 10 displays the beginning of the tendency to lower the feet, and it is from here but a short throw from the tripod (with its gradually widening base) to the broad, circular base, and from the pricket top to the socket top. Similarly, there can have been little, if any, lapse of time before the adoption of the latter.[1]

Figure 10.

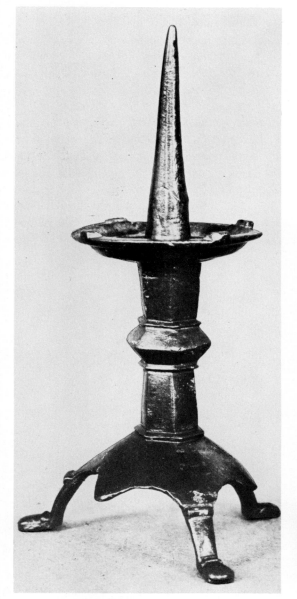

Figure 9.

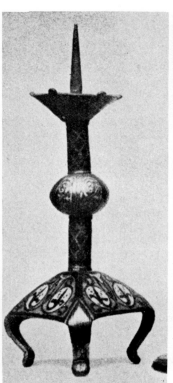

Figure 9a.

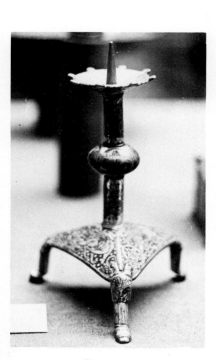

Figure 9b.

1 Curle, op. cit.

31

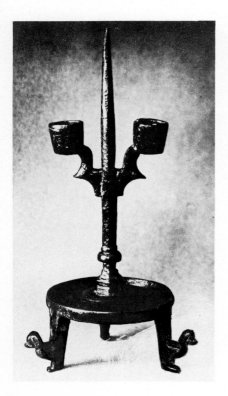

Figure 11.

As these early candlesticks have been excavated in such widely separated areas as London, Wigtownshire (Scotland) and Yébleron (France, see Chapter Four), and Limoges, it is not possible to suggest any national trend in design; it is probable that the close association that existed between Britain and the rest of the European Continent enabled these pieces to be transported from one side of the channel to the other, and, only later, for each to have been further developed by incorporating variations necessitated by the local characteristics of the wax or tallow candles with which they were to be used.

Because of the lack of any reliable or factual evidence only a provisional dating — between the 13th century and the middle of the 14th century — has been allotted to these types by most writers, based on general characteristics, and there would seem to be no reason to quarrel with those findings.

We have seen that candle-holders with either pricket or socket tops, with identical, or nearly identical, stands, were produced coevally, and if one accepts the premise that the quality of the wax or tallow was the reason for the dissimilarity of the holder, this is all the more emphasised by the production of further types incorporating both pricket and socket holders in one piece (see figures 11 and 12).

It is at about this point in time that the triple-footed base begins to disappear, and a full-skirted flange is introduced beneath the circular tray-base. The first step in this direction would seem to be that shown in the socketed stick in the next chapter (figure 25). From here on, too, the socket itself becomes more frequently used for domestic candlesticks.

An example of this base, in conjunction with a pricket-holder, is the pewter item (figure 13), only 5¾ inches high; with this bold pricket stem one would expect to find a wider "shelf" on which to stand the candle,

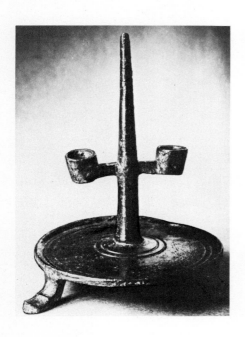

Figure 12.

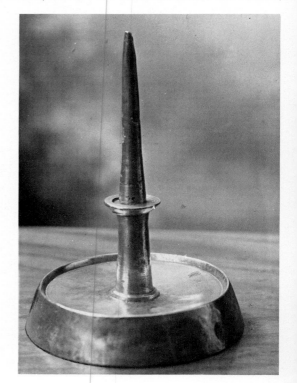

Figure 13.

and it may well, in fact, once have had a separate disc of metal with a holder in the centre, which could have been placed over the pricket spike and allowed to rest on the small node in the stem. Another, and possibly a more likely, explanation is that it may once have been accompanied by a separate branched double candleholder fitment which would have converted it to a 'stick of type similar to those in figure 12. Such loose fitments are well-known on the "Flanders" types of only a few decades later, and will be found illustrated in Chapter Five.

The slightly more ornamented base of the candlestick with animal heads projecting from the feet (figure 11), seems a reasonable "first step" towards the more stereotyped knopped and balustered column pricket holders which follow.

From here on the trend is set: first, a hollow, moulded, conical foot (figure 14), followed closely by that with *lion sejant* supporters (figure 15), and later examples with unfooted bases (figure 16), or set upon three

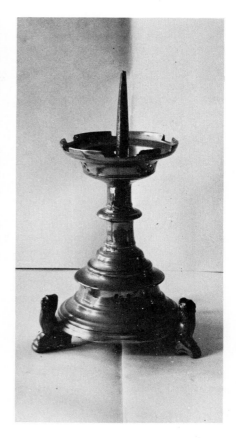

Figure 15.

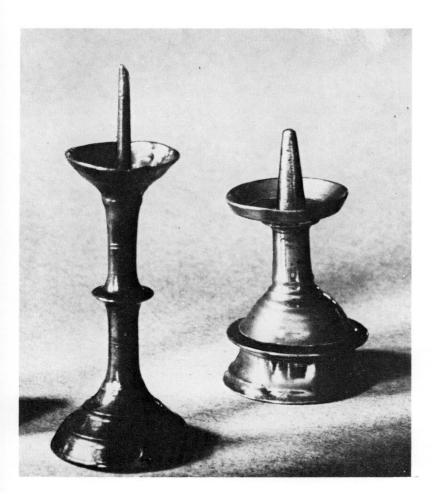

Figure 14.

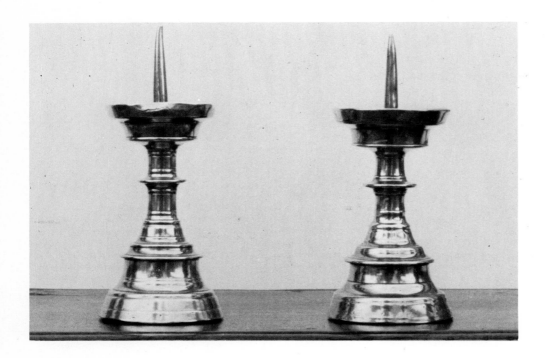

Figure 16.

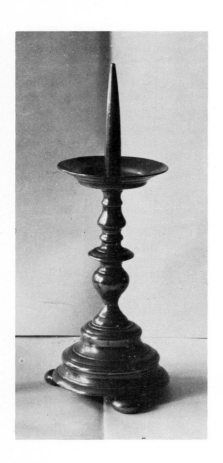

Figure 17.

globular or flattened "button" feet (figure 17).

The heavily constructed pricket-stick already referred to (figure 15), although not the earliest, is a good example of this group, and perpetuates the "battlemented" grease-pan, first seen in the "Limoges" specimen.

Up to the end of the 16th century it is rare to find any candlesticks of small size for domestic use with feet of any kind, whereas the taller prickets for altar use continued the feature for many more decades. Although the pair in figure 16 have been described as having plain (unfooted) bases, there are, in fact, traces of metal adhering to the underside of the foot rims which indicates that they, too, once had three feet, perhaps of ball formation, which may have broken away in the course of years of hard usage. Although varying slightly in size and detail of the mouldings these are, nevertheless, undoubtedly a pair, the differences being accounted for by vagaries of the lathe-operator when trimming the rough castings.

It might be expedient here to digress for a while to mention that it is a rare thing to find *absolutely identical* pairs of early 'sticks for the reasons stated, and it is this very characteristic which lends so much charm to the individually finished examples made before the days of intense mechanisation.

Yet another pointer to a more leisurely age is the incidence of a candlestick with one of its sections (in cases, of course, where made of more than one casting) of a slightly different colour of alloy from that used in another part. Here it is merely indicative of the fact that the brazier has made his various sections from batches of alloy varying in their percentages of ingredients. It will be readily understood that in the workshop it would be expedient to cast many dozens — perhaps many hundreds — of a section whilst the mould was still available (and hot),

and it may well have been that another section would have to be left over until the next day, or week, by which time an entirely new, and slightly different 'mix' was in the pot.

To return to the subject in hand! It would seem that the foregoing brass specimens may be dated from the middle of the 15th century, some, perhaps, a little earlier, and one can see no reason at all why they should not be considered English, despite the fact that closely comparable specimens have been found on the Continent, in both brass and pewter. The more ornately knopped examples in figures 18 and 19 are somewhat later in date, although it is evident from the general character of all that there can be no great difference in period between them and the foregoing. These slim examples are seldom met with in England, and a Venetian or German origin is thought to be more likely. It seems probable that a date c.1550-1600 can be placed on them. Much remains to be learned of the provenance of many of the later pricket forms we know today; they were in use over a long period after the introduction of the socket types, in Italy, Germany and the Low Countries, and similar forms were in prolific use in Britain.

One example which does not seem to fit into any hard and fast category, and is, therefore, difficult to assign to a precise period, is

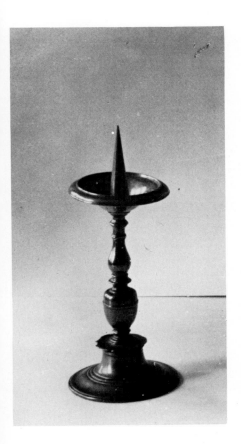

Figure 18.

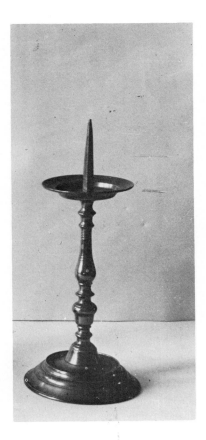

Figure 19.

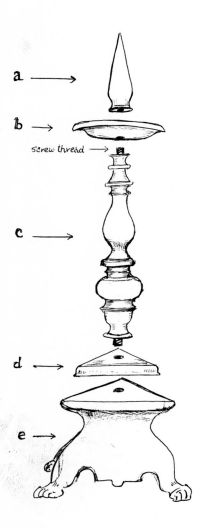

a →

b →

screw thread →

c →

d →

e →

Figure 20 (component parts).

shown in figure 20. This is made of a soft, deep coloured alloy, heavily cast in five sections; the baluster column itself contains an iron rod, the ends of which protrude at top and bottom, and upon which hand-cut screw-threads have been imposed. The five component parts were cast separately and are fitted together as shown in the accompanying drawing, the top thread being inserted through a hole in the drip-pan and screwed into the heavy pricket spike; the lower thread passing through a triangular casting (d), and fixed by a crudely cut nut beneath the hollow, triangular foot.

It seems that the column (c) was cast with a hollow centre (it could, of course, have been drilled later), and that the iron rod was then inserted and driven well home; this is indicated by a lack of fusion between the coppery alloy and the iron, which can be seen at both ends.

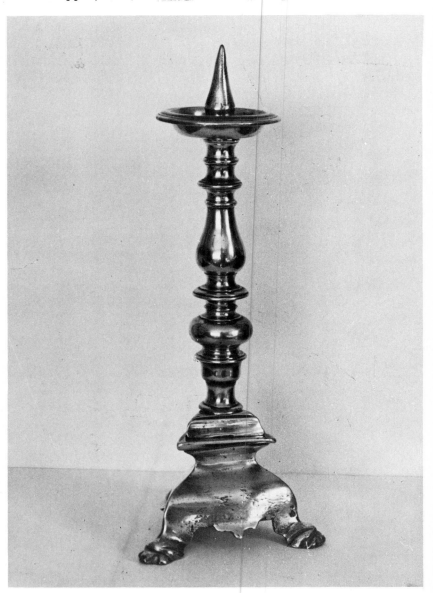

Figure 20.

It would, however, have been quite a simple process for the iron core to have been placed in the mould before the non-ferrous metal was poured in.

The spreading triangular base of this example, as also the more simple tripod bases of earlier specimens, is essentially functional, and enables them to stand more firmly on the rough surface of ancient wooden furniture, or upon cobbled floors, than would a circular, or smaller, foot. The only ornamentation is the crudely shaped "tongue" at the base of each flange of the foot, which is obviously a heritage from a much earlier period. A provisional dating, in the early to mid-16th century, has been allotted to it.

The fine pair of tall pricket-sticks in figure 21 are 12⅜ inches high, with a base spread of 5⅜ inches. They are of particular interest in that they display a base of unusual form for pricket-holders. The drip-tray around the perimeter of the "bell-shaped" foot is a feature of many Venetian and other brass and pewter socket candlesticks referred to in another chapter. In fact, the lower half casting of these prickets, from the thin centre knop downwards, could well have been used to produce such types. These prickets are unlikely to date prior to 1550, and could be dated more accurately as c. 1590-1600, in conformity with their socketed contemporaries.

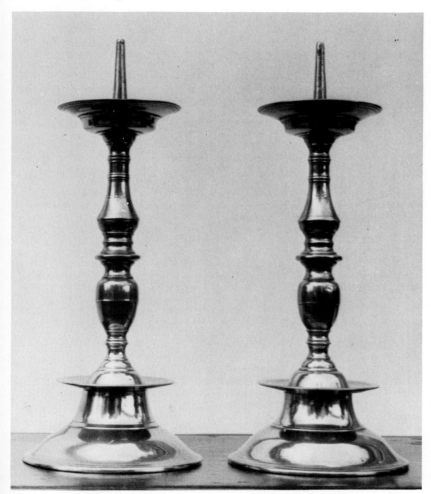

Figure 21.

4

Socket Candlesticks of the 14th to 16th Centuries

Group One

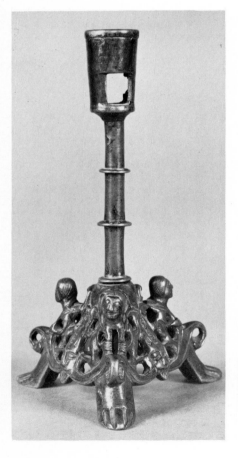

It is clear that the types of all European candlesticks have derived from two main sources; one perhaps originated from the Romans, and reached the shores of France in the form of the tripod. With this form, and its evolution, we shall deal in this chapter, and allot it the title "Group One".

Group One later sub-divides into two main streams and several smaller tributaries; the common source of which was the flat circular, "discoid" base, supported on three short feet. This type was a natural evolution of the primitive tripod, and seems to have reached most European countries by the middle of the 14th century. From this practical form logical conclusions may be drawn to show how, in England and on the Continent, the succeeding types emerged, each with its own national characteristics, and each taking influence from yet another source as time progressed.

This further source of influence was that from the Near East, and stems from a quite distinct and primitive form known to have been in vogue for several centuries before its adoption, and adaptation, by Europeans. Suffice it to say that the influence was so insinuating that, although it crept in almost imperceptibly at first, it later came to dominate to such an extent that it can be seen, in one form or another, in virtually all examples, of almost all nationalities, for the next two or three hundred years. This later development will be dealt with in the next chapter, as Group Two.

It is generally agreed by most writers on this subject, including Alexander Curle, that the socket candlestick did not come into general use until the 14th century, but since this includes a period of one hundred years, it is necessary to seek more precise chronological "pegs" upon which to hang our first examples. Mr. Curle was prepared to exclude the zoomorphic type, i.e., that of an animal with a socket on its back or combined in some other way, as possibly being related to the previous century. The Romano-British pewter example, excavated in Bath, Somerset (frontispiece) clearly establishes that some, at least, must considerably antedate the 14th century. It would, therefore, be truer to say that the candlestick *with a socket holder,* on a column with spreading foot or tripod base, is only rarely found to be of a date prior to the beginning of the 14th century. One such candleholder, in bronze (figure 22) has such a close affinity with the Gloucester candlestick, by

Figure 22.

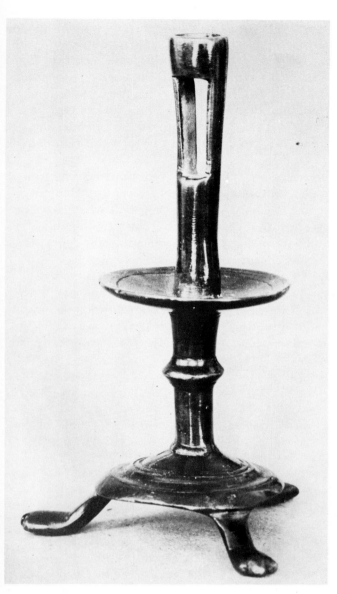

Figure 23a.

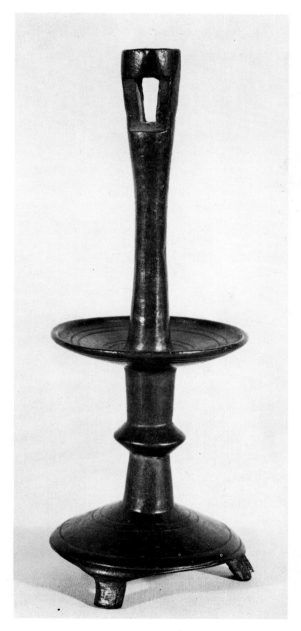

Figure 23b.

virtue of the intricately entwined branches and incorporation of "demons" in the tripod base, that it must be of closely comparable date with it and thus can be placed in the early 12th century. The workmanship in the detail lacks the supreme artistry of the Gloucester example, but seems undoubtedly inspired by it. An unaccountable feature is the severity of the column and the plain socket with large rectangular lateral apertures — these are redolent of the "Flanders" type and would not be expected to have come into use for another hundred years or so.

In the previous chapter we have traced the development of the tripod to the low, skirted, circular foot, and our first 14th century example of the socket type is that in the Cluny Museum (figure 7) which we have dated as of the first quarter of that century, say c.1300-25, but this is an isolated case, and it would seem that our subsequent socket types stem from about the middle of the century.

The first examples we find of a socket with a base similar to that of a pricket is shown in figure 23a (compare with figure 10). One would date 23a at 1350 and 23b a little later as the feet are lower and nearer extinction. Similarly, and doubtless of coeval period, we have the example of the broad saucer base (figure 24). We have shown in

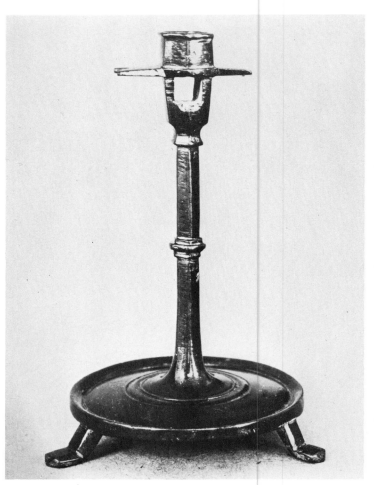

Figure 24.

the previous chapter how these bases rapidly developed into the saucer-shaped tray on full skirted flange (see figure 13 and the comparable base with socket top, figures 25 and 26).

Up to this point we have dealt with types, both pricket and socket, which might have been produced almost anywhere in Europe; that in figure 27, for example, from the H. Willis collection (now in the London Museum), and two others (not illustrated here), one from a hoard found in Fécamp, and the other from Yébleron, France. Drawings of both the foregoing are in the Mediaeval Catalogue of the London Museum, Plate XXXIX, although the pieces themselves are still retained in France. The fourth and fifth examples known to the writer are, firstly, that shown here, figure 24, in the Verster collection, and the other in the Cluny Museum; both the latter have a hexagonally cast stem and display a knop, or multiple moulding, halfway down the stem. This knop would seem to indicate a slightly earlier date for these two, since it appears in practically all earlier forms.

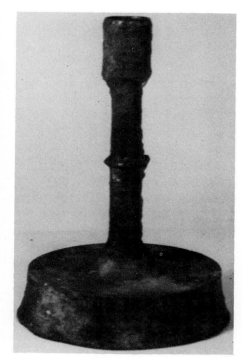

Figure 25.

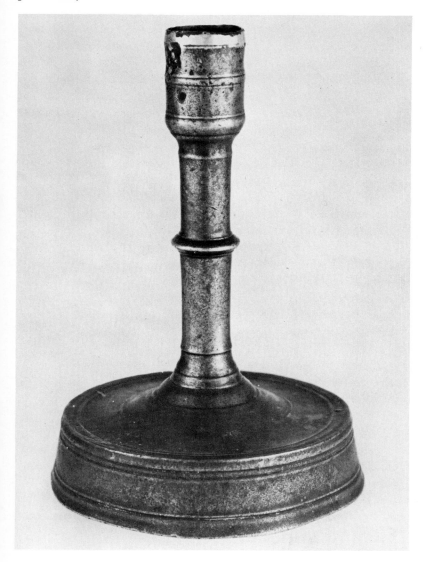

Figure 26.

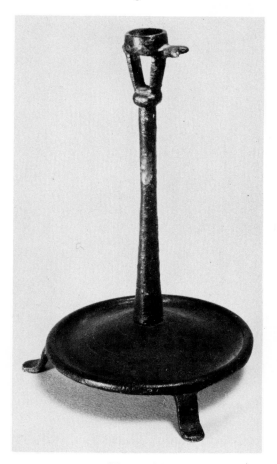

Figure 27.

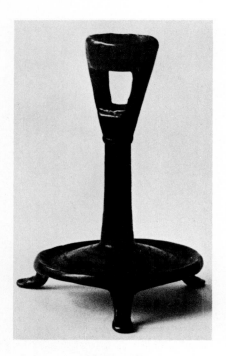

Figure 28.

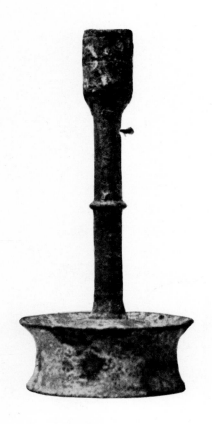

Figure 29.

A feature to which particular attention is drawn are the "wings" or flanges (some with a V-shaped incision) jutting from the sides of the socket in each of the above. Their purpose would be, apparently, to enable the candlestick to hang from the wall, from a protruding bracket with a U-shaped opening, and thus to be taken down and carried from place to place.

The same difficulty of proving a national characteristic befogs our consideration of the following example, figure 28. This is closely comparable in form with those just examined, but lacks the "wings" to the socket, and is also of very much smaller proportions, being but 3½ inches high. This specimen was excavated in London (now in the Guildhall Museum); it has hexagonal outer edges to the socket. An almost identical example, only 3 inches high, is shown by Verster, which he attributes to a Dutch origin, and places in the 13th century.

It is at this point that the three feet seen on all former examples disappear, so far as the socketed candle-holder is concerned. We are now nearing the end of the 14th century, up to which time it has not been possible to draw any reliable conclusions as to the provenance of the types shown to date. Nevertheless, some indications may be forthcoming from a later consideration of the shapes of the sockets themselves.

The disappearance of feet from beneath the base plate would seem to coincide with the adoption of certain other features which enable us to see how common trends on both sides of the English Channel began to diverge into two definite streams, each of which produced its own distinct and national types,

We see how, in England, the three feet were absorbed into the low, plain, skirt-base (figure 25); in this, and in a large number of others which have come to light in excavations in London, is the proof that here is the first stabilized form to be produced in England. To some extent the adoption of this form was a return to the primitive, but it was essentially functional; the slightly upcurved top to the circular foot almost exactly follows the contour of that in figure 29. In the first instance the skirt is quite plain, virtually a section through a truncated cone, but in only very slightly later examples the edge of the "tray" begins to extend over the lower section of the base, and to become upturned at the rim, forming the first semblance of a drip-catcher base (figures 29, 30).

In these the stem is purely cylindrical, with only a single small expansion in the centre, later to become more pronounced and to form a distinct knop. The candle-holder is quite vertical and free from any ornamentation, being merely a widening out of the column itself. Note that on these English specimens there are no lateral apertures. In English specimens of this type the knop in the stem is never so protuberant as in Continental examples, and moreover it was soon discontinued in favour of a plain cylindrical stem, rarely, if ever, seen in foreign examples. In England such stems continued to be made until the beginning of the 17th century, but from about the middle of the 15th century the candle-sockets, still without apertures, begin to assume a slight convex moulding at the socket base.

These mouldings around the sockets, which become heavier, and also duplicated at the socket rim in still later examples, were evidently inspired by the more ornamental sockets of Continental candlesticks. For a fuller understanding of how the English "stabilized form" came to influence, firstly, the Venetian makers and, subsequently, the rest of Europe, reference must be made to Chapter 5.

We must now pass on to figure 31 and follow the evolution of the low-skirted base through to the example in figure 32 (in which, incidentally, is the first tendency to introduce a "tear-drop" moulding in the stem). Note the gradual rising of the cone at the bottom of the

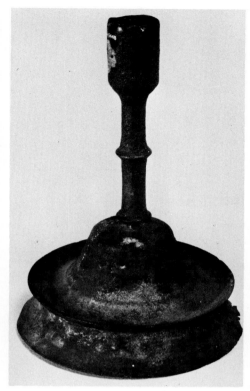

Figure 30.

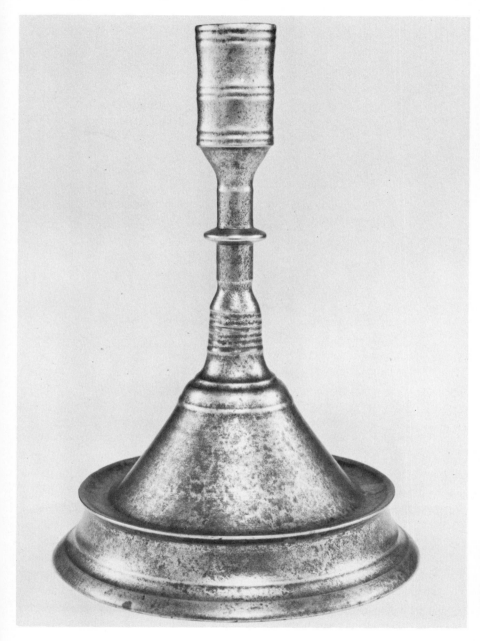

Figure 31.

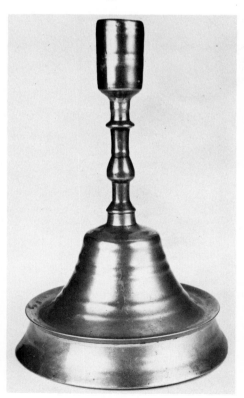

Figure 32.

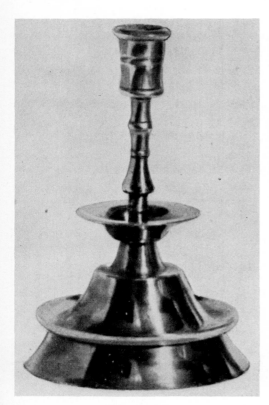

Figure 33.

column; this culminates, a century later, in the tall "bell-based" examples in figures 33 to 36, the later descent of which can be traced to a quite different, though just as logical, source.

Having now traversed one of the typological currents which, at the end of the 14th century, carried us to the British Isles, we must now back-paddle our metaphorical canoe to the divergence of the stream on the other side of the Channel. In France it would seem that the development which followed immediately from the discoid base resting on three feet was that with a very shallow depression at the foot of the column, and with only a slightly raised, sloping rim to the base, such as

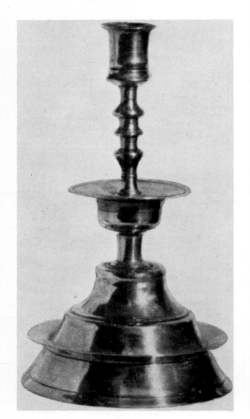

Figure 34.

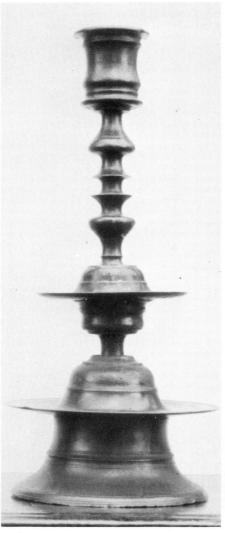

Figure 35.

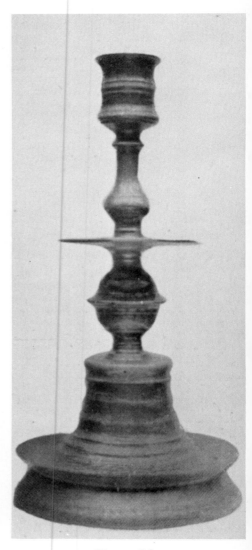

Figure 36.

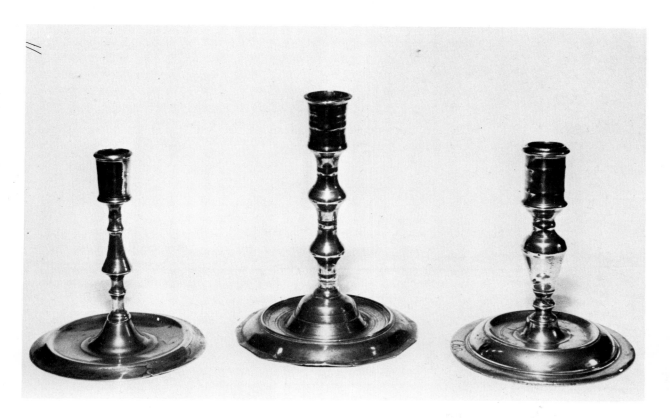

Figure 37.

that seen in the first two items in figure 37. (In this figure the 'stick on the left is almost certainly the oldest of the three, but even so it is doubtful whether it can be dated prior to the middle of the 15th century.) Curle favoured this theory of development as a probability, but he indicated that he had been unable to locate a single example which might possibly, and conclusively, supply the link between the former and the two shown. In this statement he seems to have done himself less than justice, for he had, indeed, located such an example (illustrated by him as No. 9 in his figure 2), but its significance seems to have escaped him. Had he, perhaps, found this shallow-skirted foot in combination with the plain cylindrical column (as it appears in our figure 38, and also in its still later development in figure 39) instead of with the over-decorated column with its conglomeration of lathe-turned features, he would, we feel, have been as confident as is the present writer that the evolution was established.

Figure 38 is almost certainly French because of the inclusion of the circular lateral apertures in the socket, but there were known to be at least two closely comparable specimens (both excavated in England, and formerly in the H. Willis collection) but without socket apertures, so one must, at least, hold an open mind as to the country of origin of the types as a whole. It is, unfortunately, not now possible to locate the Willis examples, but both were illustrated by Mackay Thomas (in Figs. 5 and 6 in his article in *Country Life* of August 22nd, 1947, entitled "Early

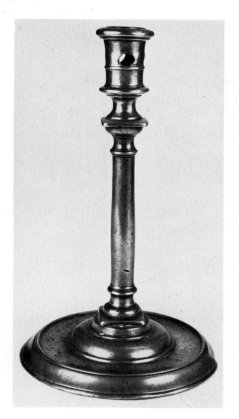

Figure 38.

45

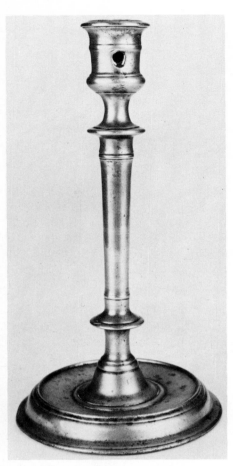

Figure 39.

English Candlesticks"), and illustrated here as figures 40 and 41. A significant detail in the Willis examples, and one which is perpetuated in the French specimen, figure 38, is the entasis (the swelling outline of the shaft of a column) in the stem itself; this has not been found on examples of later resurrections of this form in the 18th century. Brief mention must be made of the squared knop which is incorporated at both top and bottom of the column of the latter; it plays no significant role in design development, but it does, nevertheless, appear in quite an appreciable number of specimens of this particular form and date, and can, in itself, assist one to confirm its early manufacture. The squared lower knop appears again on a quite different type (see figure 150).

In Chapter Seven (Heemskerk types) we shall again refer to this identical shallow-skirted base, and to the part it plays as a link between the cylindrical columns of the mid-16th century and those which incorporate a rudimentary drip-catcher placed in the centre of the otherwise plain column, and which, still later, evolve into one of the most prolific European forms.

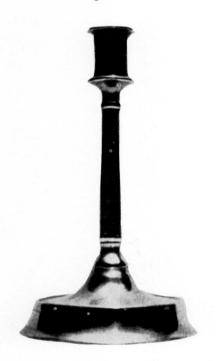

Figure 41.

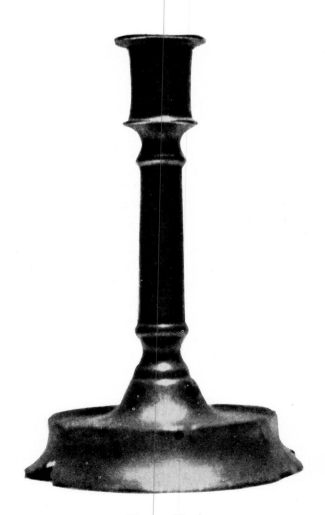

Figure 40.

An unusual development of the low, shallow-skirted foot, but in this instance with rising conical centre, is shown in figure 42. The central cone is of slightly more exaggerated form than that of the middle example in figure 37, but the other features of the base, including the ovolo moulding around the depression and the flanged outer rim, must indicate a very close relationship.

In the column itself we have indications of its affinity with the "Flanders" types (see Chapter Five), but no prototype has, so far, been found of this large, unpierced, barrel-shaped socket. The column is an adaptation of those on the "Flanders" types, but the socket, without apertures, is redolent of Venice. Here is yet another instance of the merging of the streams from various quarters of the globe, and the tendency becomes even more apparent when we come to consider our next few specimens.

We again revert to England for examples, figure 33, being, in fact, virtually identical with our figure 32, but with the addition of a deeply cupped grease-pan below the knopped column, and on the socket of which now appear the everted rings of ornamentation referred to earlier. Nothing more remains to be said of this item, since it speaks for itself as the progenitor of those which follow.

There would seem to be little doubt of the English provenance of these specimens with rising cone, all of which display the characteristic primitive "tear-drop" knop; in the case of figure 35 this is also shown inverted at the lower end of the column. For any who might still be sceptical of the provenance claimed in respect of the foregoing, the next example should set their minds at rest. This particular item, figure 36, although perhaps slightly later in date than those just considered, has all the features which enable us to fit it into the evolutionary channel. The knop below the grease-pan is an importation from the Netherlands, seen to better advantage on the "Heemskerk" types which are contemporary with it. Encircling the base of this candlestick is a relief-cast inscription which reads:-

IN YE BEGYNNYNG GOD BE MY (sic); this has been interpreted to mean IN THE BEGINNING GOD MADE ME. This superb piece is to be seen at the British Museum in London, and the authorities assign it to the 16th century by virtue of the style of lettering, and the mode of spelling.

From here on we are concerned with Group Two and the types which originated in the Near East, via Venice, and to which were added many of the features which had formerly evolved quite independently in Europe; in particular, the so-called "Hollow Conical Based", the "Bell-based" and the "Trumpet-based" types, each of which will receive a chapter to itself.

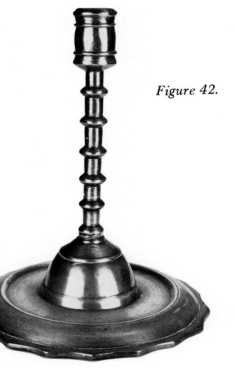

Figure 42.

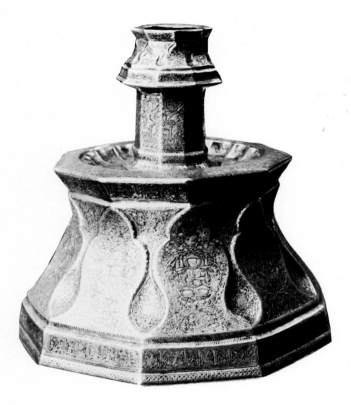

Figure 43a.

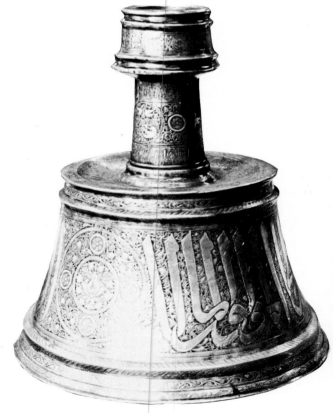

Figure 43b.

48

5

Candlesticks with Hollow Incurved Conical Bases Group Two

We left Chapter Four having explored the transmutations of Group One up to a point where the influences of Group Two begin to infiltrate, and so, in this chapter, we must retrace our steps to about the middle of the 13th century, and to Persia, for it was there that the progenitors of the conical based types were born, albeit they did not begin to have any great influence for another century or so.

Early Persian and Egyptian candlesticks are shown in figures 43a and 43b respectively. A further example, dated 1297, will be found illustrated in the *Catalogue de Musée Arabe,* Plate XXX; the earliest known specimen predates this by half a century. The basic features are a thin, flat, circular wax-pan, a short circular stem, and a socket of somewhat larger diameter with mouldings at top and bottom. In Persian literature there are sufficient references to show that candles in the 13th and 14th centuries were of wax, the summer heat in all probability rendering the use of tallow impossible. Thus the more simple extraction of the wax candle-end obviated the need for any perforations in the socket, and the greater firmness of the wax, with its diminished liability to gutter, rendered unnecessary a lengthened stem and a saucer-shaped wax-pan.

Even in the opening years of the 13th century the Venetians, by virtue of their concessions in this region, supplied goods and transport to the Crusaders and pilgrims, and it is probable that they brought back examples of these early candlesticks, for which they had supplied both the wax and the candles.

We know, for example, that they brought to Venice oriental craftsmen to work there in the 14th century, and signed and dated examples of their work, in particular of the early 16th century, by one Mahmud al-Kurdi, may be seen at the British Museum. Thus it is to Venice that we must look for the first examples of the European form, and our search is immediately rewarded in the evidence provided by Italian artists in their depiction of the candlesticks in use at the times their paintings were

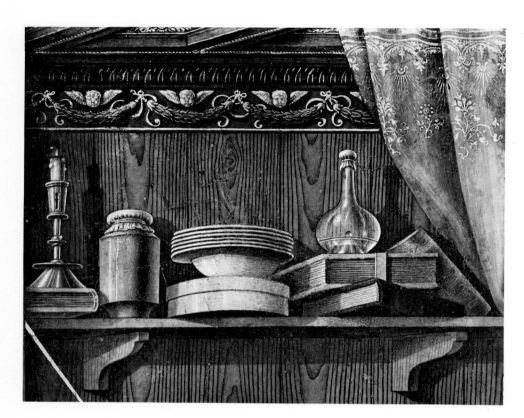

Figure 44.

executed. One such artist, Carlo Crevelli, whose "Annunciation" is in the National Gallery in London, depicted a socket candlestick in 1485 or thereabouts (see figure 44) for which we can find a very close simile.

Allowing for artist's licence, another close parallel is shown in a painting by the Dutch artist, Joos van Cleef (fl.1485-1540), in the Uffizi Gallery, Florence (figure 45). Others, of which drawings are also shown here, are that of Quentin Matsys, c.1500, in "The Misers" (figure 46) from the collection of Her Majesty the Queen, at Windsor Castle, and by Marianus van Reymerswael (fl.1521-58) in a painting in the Musée Stibbert, Florence (figure 47).

It is in the above that we have the strongest, though not necessarily the earliest, evidence of date for actual specimens.

Compare the candlestick illustrated in figure 48 with that, for example, depicted by Joos van Cleef (figure 45); the inauguration of the type cannot be later than 1540, even if we grant that the picture was painted in van Cleef's closing years. In fact, there is reasonable justification for considering it to be even earlier than 1485, for not only does it display the shallow, flared "skirt" below the grease-pan, it has the short cylindrical stem with only a single knop; it has also a close resemblance to the English example in the London Museum (figure 30 in the previous chapter) to which a provisional date of c.1450 has been suggested. The larger knop on the stem, and the mouldings on the socket, in conjunction with the lateral apertures, must, however, proclaim it to be Continental, probably Dutch.

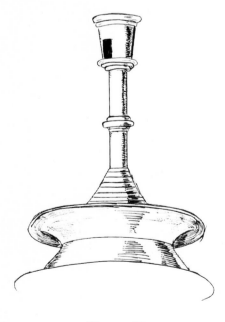

Figure 45.

Figure 46.

Figure 47.

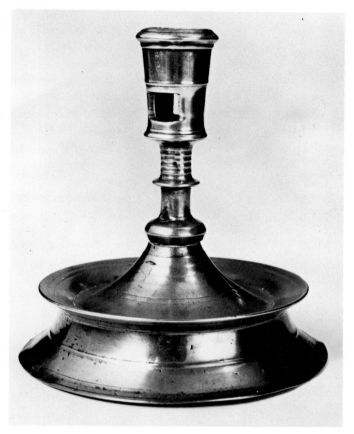

Figure 48.

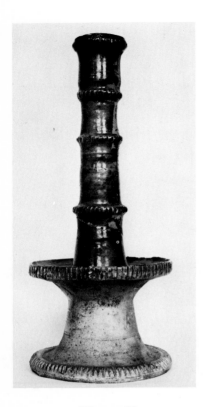

Figure 49.

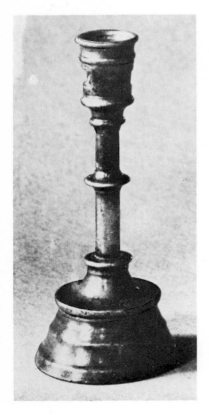

Figure 50.

With these examples from paintings, yet another simile is apparent between Matsys' painting (figure 46) and the fine earthenware candlestick (figure 49) from the Guildhall Museum. The earthenware example is tall, being nearly 11 inches high, with a base spread of 4½ inches; it is of a light buff clay, covered with a bright green glaze. This type of clay, and the "slip" glaze, are typical of many other Tudor pottery objects unearthed in England, all of which may be placed with confidence in the mid-16th century. There can be no doubt that here, again, is a representative of a type well-known in 1500, and in such universal favour that its form was adopted by the potters so far from its country of origin. From the foregoing examples it is but a short step to the better known and popular "Flanders" type, in which the thinner cylindrical stem is lengthened to about the same proportions as in the pottery example, and which may display any number of "rings" or knops, from one to five, perhaps even more. The base on virtually every one of this type is deeper in the skirt, more approaching that of its Near Eastern prototype, but tends to splay out to a greater extent. From the number that have survived it must be assumed that they were in vogue for a considerable period of time — the earliest probably of the mid-15th century, and the latest, perhaps, of the first quarter of the next century.

One of the earliest examples of this form that has come to the writer's notice is shown at figure 50 (from the Verster collection), although its origin would seem to have stemmed from the Dutch prickets (figure 14) rather than from Venice. Another early specimen is that in figure 51, also from the Verster collection. The skirt below the shallow grease-pan is shorter and plainer than that of most of its successors. It will be seen from the following examples that the skirt took on a more sophisticated form in the later years, and that the edges of the pan turned up to a greater extent. Strangely enough, this more elaborate foot does not seem to have been used on any other of the many derivations of the Persian form.

The specimens illustrated here (figures 52 and 53) bear either three or four rings or bladed knops on the stem, and such groupings of rings are the more frequently found. Heights overall range from about 7½ inches to 10 inches.

The candlestick in figure 54 is of special interest in that it displays not only three rings but two embryo "tear-drops" of the style seen on the earlier English candlesticks (figures 32, 33 and 35), although in the present instance they themselves are ridged — a most unusual feature.

There is no doubt that this general form was in production, and use, in most European countries; perhaps more prolifically in the Netherlands and France, but certainly also in England.

Inventories here refer to "Flanders candlesticks" in the first half of the 16th century, and these pieces would doubtless have been in use for a few decades prior to their listing.

Some indication of nationality may be deduced from the shapes of the candle nozzles; those of Flanders and the Netherlands, in all probability, are flared outwards at the top, and have a heavy convex moulding at both upper and lower edges, whilst the rectangular apertures are larger, whereas the English favoured the more vertically cylindrical socket with

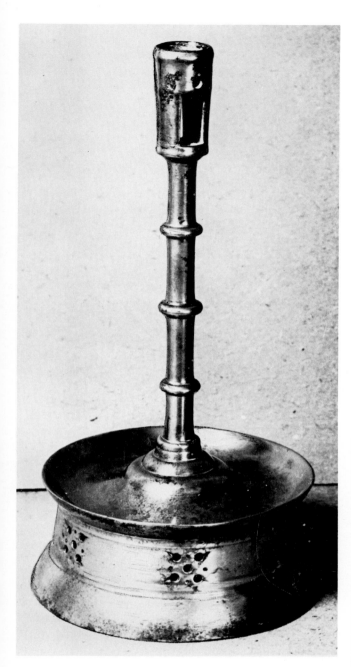

Figure 51.

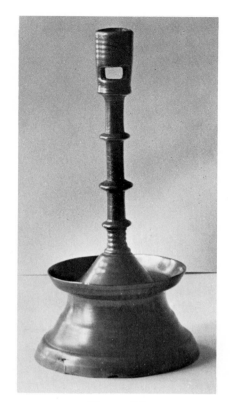

Figure 52.

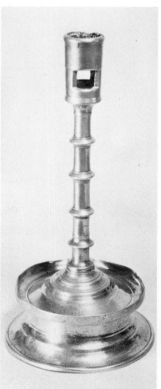

Figure 53.

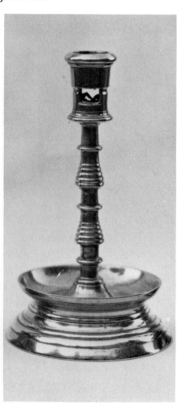

Figure 54.

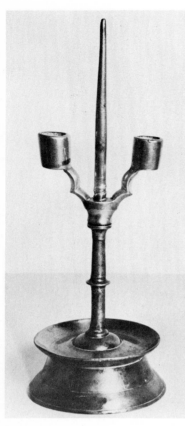

Figure 55.

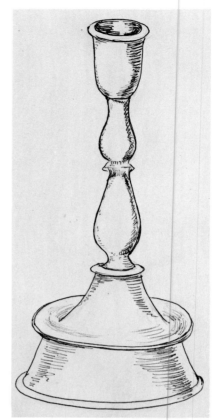

Figure 57.

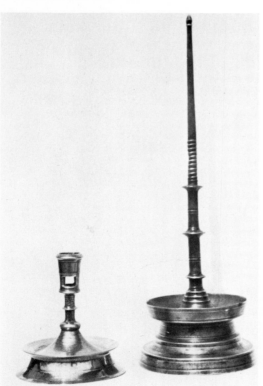

Figure 56.

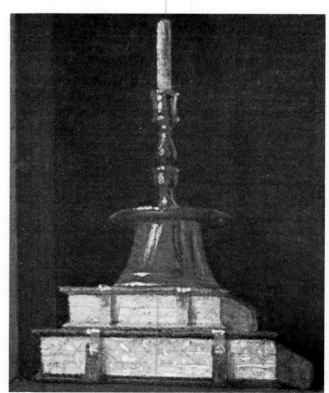

Figure 58.

either no additional mouldings or, at most, very much slighter convex mouldings at top and bottom — even, in some cases, with only a few shallow ridges around the circumference of the socket. In the latter it is more usual to find the two file-cut apertures slightly smaller, but this is not invariable.

Figure 55 shows a rare adaptation of the "Flanders" type in which the column has been extended above the point where the socket would normally sit, and in the centre of which a hand-cut screw thread has been introduced, to enable a twin-branched socket to be used; this is obviously inspired by the earlier Dutch examples illustrated in figures 11 and 12, although here it is doubtful if the centre spike was intended for use as a pricket. This is rather borne out by our next example (figure 56) which has a shaped finial at the top, purely as ornamentation. Note that the complete specimen is of comparable size with the single-socketed examples already shown, whereas the second item, unfortunately minus its branches, is of far more massive proportions, being 18 inches high, with a base spread of $6^{1}/_{8}$ inches — a truly magnificent piece. It can be compared here alongside the average-sized example previously shown in figure 48.

Coevally with the cylindrical multi-knopped stem other candlesticks appeared, still with the high flared skirt to the foot, but with a tall column of more ornate form, into which various baluster mouldings were introduced. The Italian painter Ghirlandaio (1449-94) depicts such a candlestick, on a shelf, in his fresco of "St. Jerome in his Study", painted c.1480 (see drawing, figure 57). Another example, with slightly more complex mouldings, in the stem, is provided by Vincenzo di Biagio (Catena), coincidentally, in his own representation of "St. Jerome in his Study", now hanging in the National Gallery in London (figure 58). The date of the latter painting has not been established, but it is known that the artist died in 1531.

Here, again, we are fortunate in finding actual examples in brass or bronze which are so close in character that there can be no doubt they represent the types familiar to these artists.

Alexander Curle shows a candlestick closely resembling that of Ghirlandaio, and the example in figure 59 is virtually identical with that in di Biagio's "St. Jerome".

A more sophisticated example, displaying similar mouldings in the same sequence as those of the foregoing specimen, but undoubtedly of Venetian origin because of its elaborately engraved surface, is shown in figure 60; this piece is in the possession of the Victoria and Albert Museum in London, where it is described as of the 16th century. In comparing these two examples one can be left in little doubt that the more "demure" specimen in figure 59 is of either Flemish or English extraction.

A feature which appears on both di Biagio's and the comparable bronze examples poses a puzzle which leads one to search for its origin. Reference is made to the wide "basin-shaped" knop at the lower end of the column; it is to be seen to better advantage in the illustrations of the two candlesticks at figures 33 and 34, in both of which the top of the "basin" is still open, and serves its purpose as a drip-catcher, whereas with those in figures 59 and 60 the complete knop is solid.

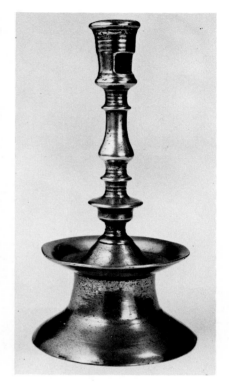

Figure 59.

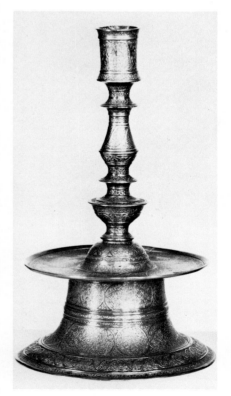

Figure 60.

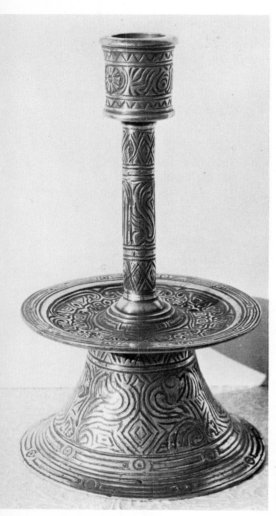

Figure 61.

This seems to indicate that, at the time of making the former pieces, the softer molten tallow needed to be caught in a fair-sized pan, but that when the latter pieces were devised about a hundred years later, this need had subsided because of the more general use of wax, and all that was found necessary was merely a semblance of its progenitor, inserted, no doubt, to conform to a well-known design.

The high incurved conical foot of the candlesticks which had found favour in Europe from about 1450 was obviously the inspiration for yet another popular series of types which can, perhaps, be even more closely related to the Persian form.

A glance at the later example of a Persian brass candlestick (figure 61) will indicate that the European craftsmen needed little other inspiration; the bases of the European counterparts (figure 62 *et. seq.*) are virtually identical; only the column is shortened, and the socket is pierced to allow the candle stump to be ejected — a feature which does not appear in the Eastern specimens.

According to some authorities, Mackay Thomas included, candlesticks with this short stem (almost non-existent in some cases) were produced in England in the reign of Henry VII (1457-1509), but the present writer would assign them to the following reign, i.e. to that of Henry VIII (1509-47) at their earliest. There is no doubt that the form was adopted universally throughout Europe, and was in vogue for a considerable period of time, for examples are numerous, their preservation due, in some measure, to their compactness and sturdy construction. There are, however, comparatively few which can be placed with any certainty in the 16th century, and the writer is of the opinion that a great many of the existing examples should be placed somewhere near the middle of the 17th century, for in the Latin countries, Spain and Portugal in particular, their popularity persisted long after they had ceased to be used elsewhere.

The earlier examples are of fairly heavy construction, the bases being thickly cast, and not thinned unduly by the inevitable lathe-trimming processes. In later examples the base casting has been pared down to a

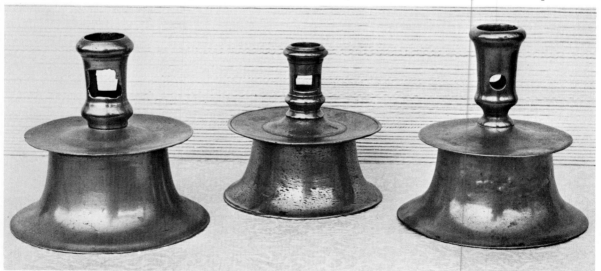

Figure 62.

greater extent, firstly because the metal is of better quality and could thus withstand such drastic treatment, but also to save as much as possible of the better metal. On the more delicately trimmed bases it will be found that ornamental mouldings have been introduced around the splayed edge of the foot, and incised rings cut around the surface of the drip-catcher. That in figure 63 is an example.

Figure 62 shows a group of three 16th century specimens, varying only slightly in detail, one from another; note that the sockets of the first two are virtually cylindrical, a feature pertaining to the earlier examples, and which is thought to indicate their English ancestry. Most examples of this type, of whatever nationality and period, have large square-cut lateral apertures to the sockets, made by a simple file cut across the cylindrical socket, but very occasionally one may be found with large round apertures, as in the specimen on the right.

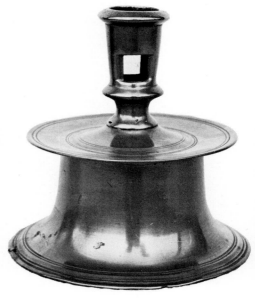

Figure 63.

The heavy ovolo moulding at the upper edge of the sockets is constant in all examples, although some have this in a more pronounced form than others. That in figure 63, for example, and many others to be found in collections, will be seen to have sockets with the far more pronounced everted moulding below the apertures, and, moreover, the sockets taper outwards slightly towards the top — both these features may be considered indicative of Continental origin, and of later date.

To the chagrin of many of the older collectors, who diligently gathered their specimens together as and where they could be found (and they were, even thirty or forty years ago, exceedingly hard to come by), large numbers of this form have been brought into England in the past decade by travelling antique dealers, who have, they say, found them principally in Spain and Portugal. It has been suggested that, as a result of the gradual modernisation of the many monasteries there, and the installation of electric lighting in the present century, large numbers of candlesticks have become redundant; bearing in mind that one, at least, would have been required in each of the hundreds of monks' cells. It is probable that since they went out of use they have been stored away in the cellars for several decades, and forgotten, and have been brought to light again only by the temptation of the financial rewards offered.

Because such numbers have come on to the market only recently it would be wrong to assume thereby that they are necessarily late in date of manufacture, or that they were unquestionably products of the Latin countries. It is far more likely that they were of more Northern European origin, and had been exported, in most cases, several hundred years earlier.

Nevertheless, there are some examples, closely allied so far as the foot shape is concerned, which one would be justified in attributing to the southern regions of France and the Latin Countries, such as those in figure 64. In these the sockets are of quite different character, being, in the main, larger, heavier, vertical-sided, and adorned with three bold bladed rings of ornamentation in equidistant positions. Another characteristic is that, with only rare exceptions, they have round apertures (as these) in the lower section of the socket. On all the specimens referred to above there is a short stem, of approximately one

Figure 64.

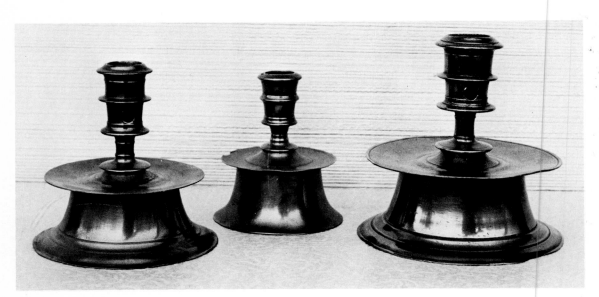

inch in length, rising from a wide ring-knop at the point where the stem enters the centre of the wide grease-pan.

Three variations of this appear in the specimens in figure 65, the first of which has two rectangular apertures in the lower section and two round apertures above, whereas the second has none at all; the third has a much plainer socket, with only a mere semblance of adornment at the top and bottom, and on all three there is less of an expanded flange at the fixture point.

No great significance can be attached to these unusual features, although one might be inclined to place the first and third items a little earlier than the other, though all would seem to fall within the first half of the 17th century.

Many of the fore-going types bear a small punched maker's mark, struck inside the base on the underside of the grease-pan; when found, they add ·considerably to the interest of the piece itself, but unfortunately provide no clue to the origin of the maker.

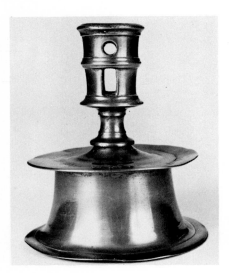 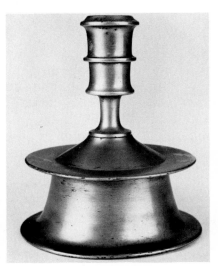 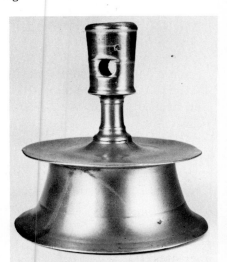

Figure 65.

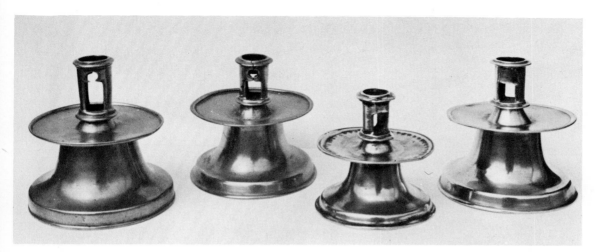

Figure 66.

The four candlesticks shown in figure 66 are almost certainly Continental, either Spanish or Italian; they are made of a particularly soft and beautifully textured pale coppery metal, almost gold-like in feel and colour, and they vary from previously illustrated types in several other respects. The bases have a short, vertical "step" around the edge of the foot, whereas all former specimens have a gradual curve which extends to the edge of the foot rim. The sockets are completely vertical with a double ogee moulding at top and bottom. The opening for the candle at top is circular, as might be expected, but the sides of the socket, which, in the illustration, might appear to be circular, are, in fact, of hexagonal shape, although in these examples almost imperceptibly so, due to wear from continual polishing. Fixture of the socket to the base is by riveting; screw threads have not been found on this type.

The sockets of those shown all have two large square or rectangular apertures, and the first two, on the left, have an additional pair of circular holes above; note that the first item has the round holes actually cutting into the rectangular openings, thus forming a "Spanish Gothic" (or "Moorish",) arch.

Alexander Curle refers to these apertures, and the present writer confirms this opinion that candlesticks with square (or rectangular) lateral openings are almost certainly of a date prior to 1600 (exceptions are, of course, one of the group illustrated in figure 65), and that when they are combined with circular holes, to form the so-called "three-cusped" arch, they are considerably earlier.

Another unusual feature to which attention is drawn is that the grease-pan in each case has a cast reeding around the edge. The third item in figure 66 has also a series of symmetrically placed punches around the inner edge, struck from an individual die. A socket of this identical form (but pierced in the manner of the second item in figure 66) adorns our next item (figure 67), and the foot is also identical beneath the drip-tray. It is the tray itself which is unusual in its eight-pointed star form; one other of this general character has been seen, in which the edge of the tray is scalloped with about twenty small arcs.

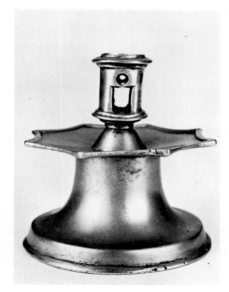

Figure 67.

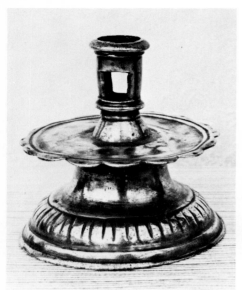
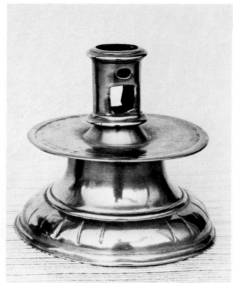
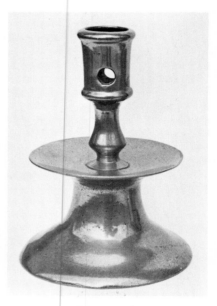

Figure 68. *Figure 69.*

Figure 68 depicts two candlesticks which, strictly, do not belong in this chapter for, although the sockets are of exactly similar form to those in figure 66, and other details of manufacture and finish are closely comparable (and thus indicate a common origin) they are set upon a base of "truncated bell" form such as will be dealt with more fully in the following pages. The indentations around the curve of the foot — in these cases made by a file cut — are an obvious attempt at simulating the cast gadrooning seen on the Heemskerk pewter specimens. A particularly attractive feature of the first item is the ornamental edge to the drip-tray, composed of sixteen small curved projections, and upon each of which a small floral motif has been punched. Although difficult to see in the photograph, the final item has a band of ornamentation around the edge of the drip-tray; this, too, is contrived by the repeated striking of an individual punch. This practice has already been referred to in relation to the third item in figure 66, and the combination of several unusual features in these pieces clearly illustrates how, at the end of the 16th century, the various streams of influence begin to merge to such an extent that national attribution becomes almost an impossibility.

In the next chapter, for example, we shall find candlesticks with the conical base, which, but for the sockets which accompany them, would have been included here.

For our next examples we can find corroboration in art, for more than one artist has depicted a candlestick of which those in figures 69 and 70 are close similes. The first of our brazen specimens has several features which might lead one to the conclusion that it should have been placed, in date and character, near to the tall Flemish type in figure 59; it has the slim, heavily cast base associated with that item, and the stem, although shorter, displays a form of "teardrop" knop we find on considerably earlier pieces.

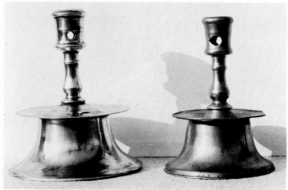

Figure 70.

The socket, too, is virtually identical with that on many 15th century candlesticks; in fact, had the socket been pierced with rectangular apertures instead of round, it could have been datable close to the beginning of the 16th century. As it is, the circular apertures must be our guiding feature in this respect, for it is unlikely that any candlestick prior to the last quarter of the century would have been so equipped. The two items which follow have stems and sockets of equally early form, but set on to bases of somewhat later style, that on the second piece being not too unlike those of the group in figure 66, although, in the present instance, it is cast more heavily, is of more yellow, hard brass, and has a shallower "step" around the lower edge. In St. Nicholas Church, Aberdeen, in the drum aisle, is a memorial brass to Dr. David Liddell, who died in 1613, and upon whose grave plate is shown a candlestick of which figure 71 is a drawing; similarly figure 72 shows another of close character, depicted by Gerard Dow, in a self-portrait of 1647, and the same candlestick is shown again in his "Young Mother", at the Mauritshuis, The Hague, painted in 1658. The date, 1647, for the painted example, enables us to place these brass specimens in the first half of the 17th century, at latest.

Yet another example can be dated from the artistic impression of Gerard Dow, who, in his "Kitchen" scene (1645-50), now in Copenhagen, showed the specimen drawn in figure 73; its almost exact counterpart in brass is shown in figure 74. This is also of the pale yellow alloy, and has a closely comparable socket to the former items, with two small circular openings; a short, knopped stem separates the socket from the grease-pan. This single circular, ridged knop is found on brass or bronze candlesticks of the "Heemskerk" type, in particular, and since the specimens in which it appears can all be dated before 1625, we shall assume this as the latest date for this rather rare form.

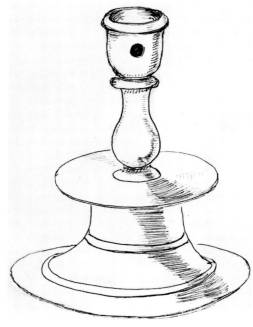

Figure 71.

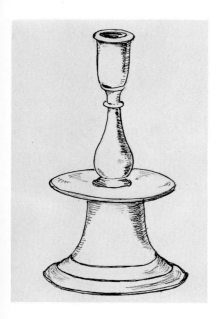

Figure 72.

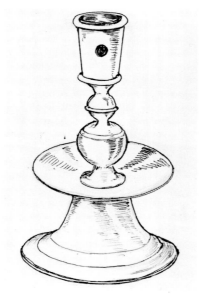

Figure 73.

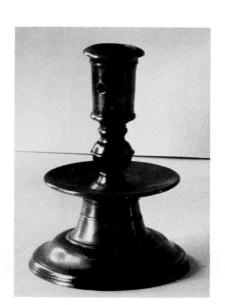

Figure 74.

6

The "Low Bell" and the "Great Bell"

Candlesticks with the above titles were recorded as having been assayed by the Worshipful Company of Pewterers of London in the year 1612, and in this chapter we shall meet with types, in pewter and in bronze, which are, in all probability, actual representatives of both these groups.

It needs no vivid imagination to understand what types of candlesticks might be defined by the term "bell-based"; the two examples in figure 75 show this far more effectively than any words could describe it. Not all in this category, however, show the bell-shaped foot to such advantage; some seeming to have the top of the bell truncated before the drip-catcher tray was imposed, whilst others appear to have merely a small conical "hump" rising from the drip-tray, quite unrelated to the

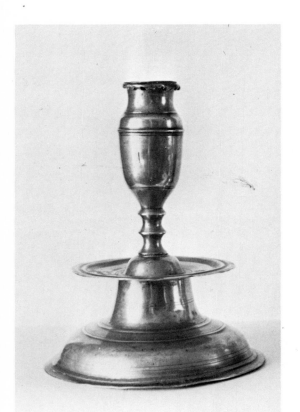

Figure 75.

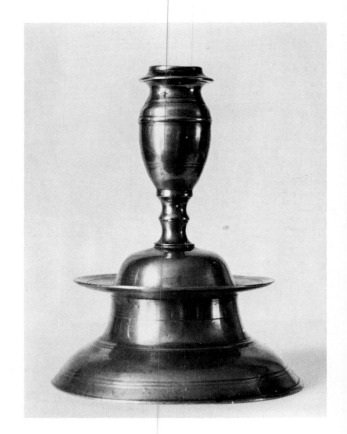

bell-like contour of the section below it. Nevertheless, there can be no doubt of the origin of the form itself. The Venetian voyagers in the 14th and 15th centuries brought oriental craftsmen to Italy, to practise their skills in the damascening of silver and other metal objects — one, Mahmud al-Kurdi, in particular, has left signed and dated examples of his work, including candlesticks of this identical form — one such pair, datable to the early 16th century, is in the possession of the British Museum. Such elaborately ornamented pieces were undoubtedly made for special purposes, or eminent personages, and hardly come within the purview of "domestic" wares, and so do not concern us here. Nor is it thought that the artisan brassworkers adopted the form during the next fifty years or so. The earliest examples we are able to show here would date from around the third quarter of the 16th century, and from that time onwards, in addition to the specimens with an undoubted Venetian origin, we find the form adopted in most areas in northern Europe, from Barcelona to Britain, and from the Netherlands to Norway. As we shall see, the form had a long run; Swedish pewterers were still making candlesticks in almost this exact form as late as 1714.

The illustration in figure 76 is of two pewter candlesticks from the ill-fated Heemskerk expedition of 1596, (referred to in detail in Chapter 7), and because they can be dated with certainty in the last quarter of the 16th century, they are good examples with which to commence our study of this group.

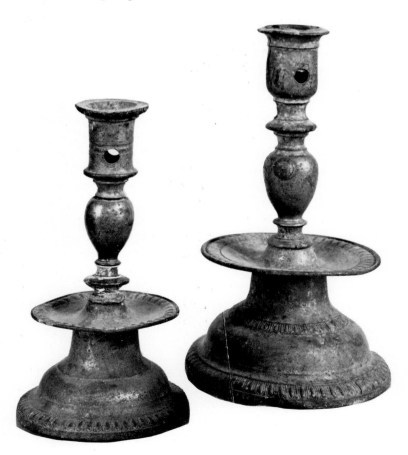

Figure 76.

The columns of these incorporate a true "egg-shaped" knop which, though sometimes in a more modified form, seems to prevail in most of the examples with this distinctive foot.

Without the irrefutable evidence of their existence before 1596 they might well have been considered of some fifty years later, at least, for they display some features which we have come to expect to find only in the 17th century, and others even later. The sophisticated sockets, with wide, everted flange on the first, and the curved lower edge of the second, in combination with the two small, circular lateral apertures, must cause us to revise the standards by which we have become accustomed to judge. These anomalies show, only too conclusively, how the designers over the next hundred years or so reverted to the older craftsmen for their forms, and that there is some truth in the adage that "there is nothing new under the sun".

Pewter candlesticks of a period prior to the middle of the 17th century are exceedingly rare, probably not because such things were not made in abundance, but because their comparative frailty in comparison with others in brass and bronze has not been conducive to their survival. The fact remains that, whatever the reason, there are far more examples existing in the harder alloys than in pewter. Both examples in figure 75 are believed to be of the late 16th century, that on the left being of high quality brass or bronze, trimmed by lathe-turning to almost card thickness, and thus very much lighter in weight than others of poorer, pale calamine brass, which just could not stand up to such radical treatment. One in the latter category is shown on the right in the same illustration.

The bell-base and the drip-tray are comprised of a single casting, and the socket and stem another; this is fixed to the base by a screw-thread into a threaded hole at the apex of the bell. In some cases a crude nut is to be found fixed to the "male" thread, and it is often difficult to decide if it was originally there by intention, or whether it is "one of the inventions mothered by necessity", or, in other words, had been fixed at a later date because the hole had become too worn to hold the screw securely. It would seem that screw-threads were almost universally adopted on this form, for they are found in combination with most of those with true bell-shaped bases, but not, strangely enough, on those with similar sockets but flared conical bases (as those in figure 83).

The significant features of the two items in figure 75 are, firstly, the elongated "egg in egg-cup" shaped socket, and, secondly, the incurved collar below the candle opening at top. These are exactly as shown in the first of the Venetian examples of nearly a century earlier, and seem to have been retained by makers in that area; this is still further emphasized by the depiction of an identical example in a painting, "The Last Supper", by Leonardo Bassano (1558-1623), in the Church of Santa Maria Formosa, Venice.

The Northern European brassworkers would appear to have favoured a shorter "egg-cup" from which rose a vertical collar, in which, in the majority of examples, were two circular lateral apertures.

From figure 75 we return to the pair of pricket candleholders in figure 21; in these we find almost the exact counterpart in the form of the

Figure 77.

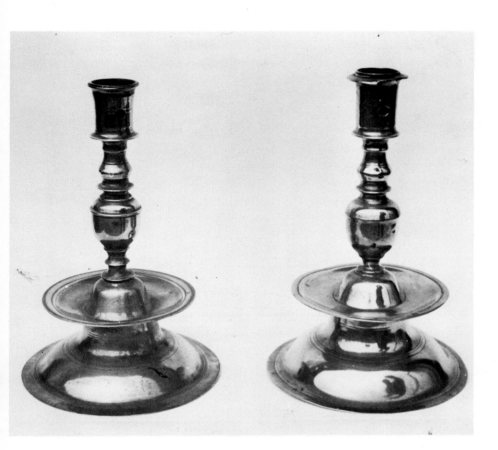

bases, and in the lower section of the baluster columns up to the central knop, almost as if a section of the original moulds could have been used to produce the shorter socket candlesticks. All four of the above are believed to be of Italian origin.

Of about the same period are the two taller socket candlesticks in figure 77; they, too, are of good quality alloy, and have been drastically thinned in the finishing process.

Despite their great similarity to each other, they are not a pair; minor differences will be seen in the turned columns and in the shapes of the mouldings around the socket tops. Both have circular openings for candle stump ejection, which dates them in the first few years of the 17th century. On the thin flange extension to the foot-rim of the example at right is a small punched maker's mark, of crossed swords and the initials "CA".

Another example which also bears a maker's mark, in this case of the initials "G.G" flanking what seems to be a human bust, is shown in figure 78. The higher bell-shaped base is truncated above the drip-catcher; the column is of much more slender construction, but it has, nevertheless, a socket of very similar character to that on the former pieces, except that it lacks the circular apertures. It is of high quality alloy, trimmed very thin by the lathe after casting. Fixture of the column is by a screw-thread.

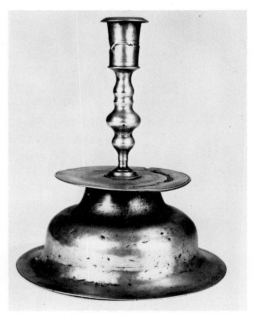

Figure 78.
A candlestick of this form is, however, in the Cooks Collection, Valentine Museum, Richmond, Virginia, and bears the mark of 'George Bischof of Nuremberg', recorded 1667-84. C.B.

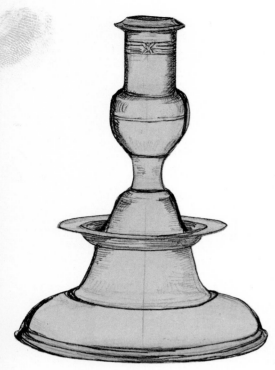

Figure 79.

Figure 80.

The following examples seem to stem from the Anglicised version of this form (shown in figures 79, 80 and 81 (pewter)). As indicated earlier, the main differences between these and the Venetian examples is the high cylindrical collar at the top of the socket; this first appears on the pewter specimen, figure 81, which several authorities, including the late H.H. Cotterell, have dated as of c.1600. It was Mr. Cotterell who was responsible for bringing this item to the notice of its subsequent owner soon after it had come to light beneath the foundations of a plumbers' workshop in Yorkshire many years ago. At an earlier date, sometime before 1904, the specimen, of which a drawing appears in figure 80, was found, together with two other pewter specimens of different character, but of coeval date, when the moat of a 16th century house at Arley, near Wigan, Lancashire, was being drained and cleared of debris.

Comparison between the drawing at figure 79, which is of another excavated piece from the collection of the late Mr. Alfred B. Yeates, and the actual pewter example (figure 81) will show that the two pieces are identical, or nearly so; the fact that these two, and such a closely similar example as that from Arley were all excavated in England, lends considerable weight to their claim to be of British origin. The author has noted no similar examples in either bronze or pewter, of comparable date, from any other country.

Examples of the same general character, in brass, but of somewhat later date, are those shown in figure 82; there is reasonable justification for the belief that these might have been made in Scandinavia, since they have a recorded history of having been purchased in Norway and Sweden, respectively, at a wide interval of time. The bases are very much broader than our other examples, and they display that sturdiness of character which one is inclined to associate with products of the North. Both are heavily cast, not trimmed too thinly, and have screw-thread attachment for the columns; both have lateral apertures in the upper part of the socket. The contour of the "egg-cup" knop is less elegant than that on the Venetian examples in figures 21 and 75, but more approximating those in figure 77.

Two candlesticks are illustrated in figure 83 which we are constrained to deal with in this chapter, because of the shape of the sockets, although the bases would otherwise have caused them to be considered of another group; this unusual combination of the "egg cup" socket with the incurved conical foot still further emphasises the integration of features from various countries, and amply demonstrates the difficulties which beset the student in his endeavours neatly to pigeon-hole the types which come to his notice. The example at left is of good quality yellow brass, and has a socket of very similar form to those in the previous illustration, except that the moulding around the candle-hole is flattened at the top, whereas both of the former have a "stepped" moulding in this position. If any significance at all can be placed on this feature then it would seem to indicate a Dutch influence, although the present writer would lay no strong claim to such an origin on that fact alone; there is, however, one other characteristic which places it apart from those previously dealt with here, and it is that the column of this, and of that on the right of the same illustration, has been riveted to the base in the

traditional manner. The good metal from which this was cast has enabled the maker to trim it down considerably so that now it is of fairly light weight in relation to its size, and in the process, it has acquired shallow reedings round the foot rim. The item at right is of slightly different character: firstly, it is somewhat more heavily cast, and is of a deep coppery-coloured alloy, probably of bronze; secondly, it has a socket with only the vague semblance of the "egg-cup" form; and, thirdly, the outer edge of the grease-pan is uptilted in the manner we shall observe in at least one of the undoubted Dutch pewter examples of "Heemskerk" type. All these features, in combination with the slimmer, moulded foot seem to indicate a Dutch origin, and a date prior to the turn of the 16th century.

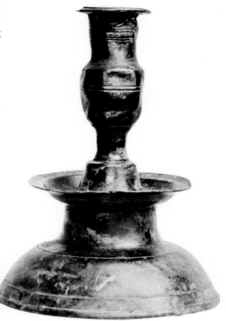

Figure 81.

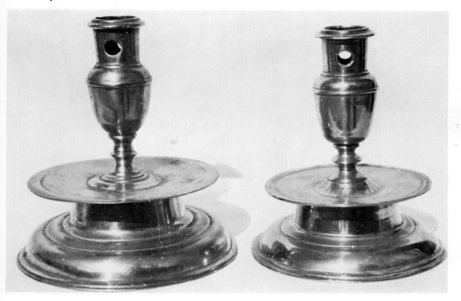

Figure 82.

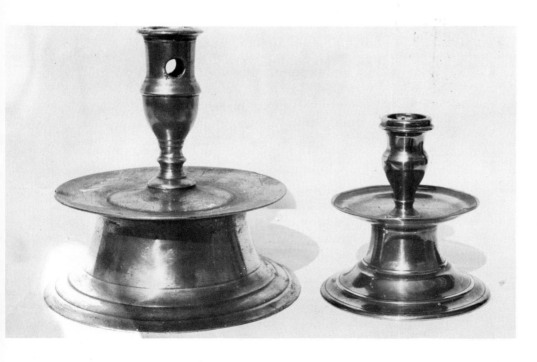

Figure 83.

67

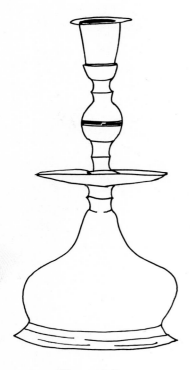

Figure 84.

Before leaving this intriguing group there is yet another feature to be commented upon in relation to the examples in figures 75, 77 and 78. In each of these the large knop is hollow, thus detracting from the weight of the finished object, whereas on most other candlesticks prior to about 1600 the columns, whether plain or knopped, large or small, were cast of solid metal. The shortage of high quality alloys, and the difficulties being encountered in their efforts to produce good zinc brass, no doubt caused the makers to experiment with a process for "coring" (i.e., producing a stem with a hollow centre following the outline of the outer shape, in order to conserve the metal). When a candlestick stem or socket was required to be purely cylindrical, no problems arose; this could be produced quite easily by the insertion of a cylindrical "plug" in the mould, which was later withdrawn when the casting was set. Alternatively, of course, the hole for the candle could be drilled out afterwards. When however, the knop in the stem was required to be hollow and with a larger internal diameter than the neck of the socket itself, then some other process had to be adopted. The present-day method of "throwing-out" surplus metal (called "slush casting") to form a hollow casting does not seem to have been used until a somewhat later period.

The five candlesticks shown in figures 75, 77 and 78 each have a feature which, although visible to the naked eye, could quite easily be overlooked, especially on an uncleaned specimen. This is a small iron, or sometimes bronze, "pin" or rod, the head of which can be seen in some of the photographs. The other end of this pin is visible on the opposite side of the candle-socket or knop, as the case may be, wherever it is placed. These marks could, in fact, be mistaken for flaws in the casting unless their true purpose is appreciated.

It is obvious that the rod had been in place in the mould at the time of casting, and that the internal portion of it has since been cut away inside the hollow knop, as it no longer runs through as a continuous bar from side to side; the roughly broken ends of the rod can, however, sometimes be still felt with the finger-tips inside the hollow candle socket or knop. A suggestion as to the purpose of this feature is propounded, and it is that, to produce a hollow casting (as stated above), the rod had been used to hold a solid clay "core" of the shape of the hollow interior in position in the centre of the mould whilst the molten metal was poured in, the clay core (and the internal portion of the rod) being later chipped away, leaving visible only the ends of the rod on the outer surface of the finished casting.

It is a notable fact that this process seems to have been used only on high quality brass and bronze specimens, and originally on those which could possibly have originated in Venice. The same process does not seem to have been used for hollowing the knops of the later specimens produced in Northern Europe; for example, the two in figure 82 have hollow sockets, of which the interior shape follows the contour of the outside, but there is no sign of the sustaining rod, and so one must assume that the "slush casting" method was used. In respect of the two examples in figure 83, however, the candle-hole is purely cylindrical throughout its depth, and this has obviously been contrived by

the insertion of a cylindrical plug in the mould, or by drilling the cavity out after the casting was made, in the manner described above.

The example we have shown in figure 78, and that drawn in figure 84 appear to be transitional links between the "low-bell" and "great bell" types we shall find in the following pages. The drip-catcher is no longer *around* the dome of the bell, but is completely above it; also the hollow foot is of greater height and eventually culminates in the characteristic "great bell" specimens, shown in figures 85 to 89. Figure 78 is of bronze and has already been described; the drawing in figure 84 is of a pewter candlestick (one of the three items from the moat at Arley referred to earlier) and of an exceedingly rare — possibly unique — form, approximately 10½ inches high, which the author has no hesitation in placing well before 1600. The author has little doubt of its English nationality.

The tall examples which follow are all of pewter, but the type is also known in bronze or copper-coloured brass. It would seem almost certain that this is the actual form referred to in inventories of the mid-16th century and in the records of the Pewterers' Company in 1612, as "great bell". It is suggested that most, if not all, of the known specimens are English. It is doubtful if the type persisted after c.1615.

The shape of the baluster knop in the column of the three items in figures 85, 86 and 89 is very close to that on some examples of "Heemskerk" type with central drip-pan, and on 16th century pewter chalices, and it has not been found on any candlesticks of any nationality after the end of the first quarter of the 17th century.

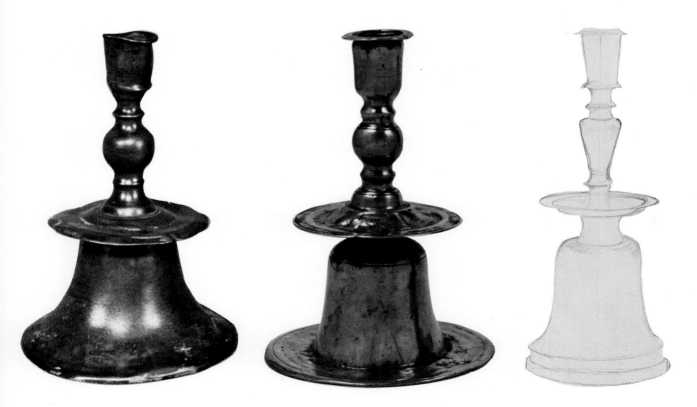

Figure 85. *Figure 86.* *Figure 87.*

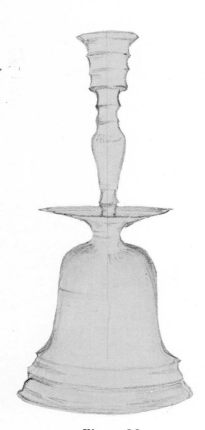

Figure 88.

The writer has been able to trace references to, or photographs of, only eight "great bell" specimens in pewter, and has been able to locate the present whereabouts of only three of them; two are shown in figures 85 and 86. Drawings have been made from poor photographs or sketches of some of the missing specimens, to show variations in the styles of the columns, the sockets, or the lower mouldings of the bell-shaped bases. The late H.H. Cotterell, writing in 1932, illustrated and commented on the example in figure 87, and remarked on the scarcity of the type, which he dated as *not later than 1600*. That drawn in figure 88 was found with two others, slightly differing, but of equally early period, in the moat at Arley. The last example (figure 90) was in other ownership, but was exhibited with the Arley specimens at the Pewter Exhibitions held at Lincoln's Inn, in 1904 and 1908, since when they have been lost to public gaze.

The known pewter examples range from about 8 inches to 10½ inches in height.

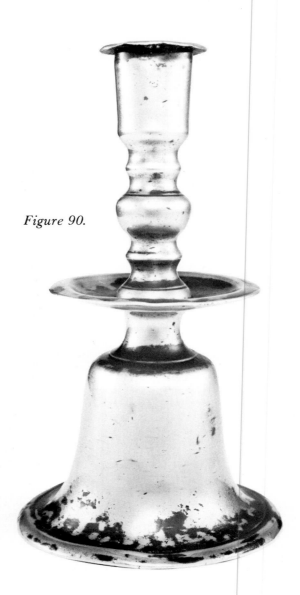

Figure 90.

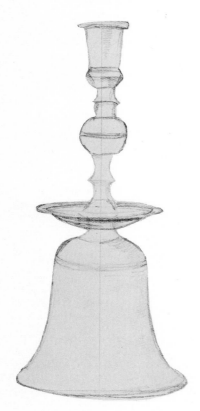

Figure 89.

7

Candlesticks with Central Drip-pan
The True "Heemskerk"

For this chapter has been chosen a type of candlestick which is, in brass, perhaps the most frequently found of all 17th century examples in England, and of which numerous specimens are also known to have been made and used in the Netherlands up to, at least, the middle of the 18th century.

There is no doubt that it was a type well-known in the Netherlands, for in 1596 a fleet of Dutch merchant vessels set sail from Holland, under the command of one Jacob van Heemskerk and a Willem Barentz, to find a route to China via Northern Asia. Among the cargo and appurtenances of one of these vessels was a large quantity of pewterware, including candlesticks — a group of these artefacts is shown in figure 91. It will be noted that in addition to four pewter candlesticks with central drip-trays there are several others of a shape dealt with in Chapter Six.

This expedition reached Nova Zembla, where it was forced to spend the winter of 1596-7, and after suffering incredible hardships, Barentz perished, and in the following spring the remainder of the party managed to get back to Holland, leaving behind them much of their gear and possessions. Nearly three hundred years later — in two expeditions undertaken in 1871 and 1876 — these relics were discovered and rescued by a sea captain from Hammerfest, in Norway, and a Dr. Gardner, from Goring, Oxford; they were eventually returned to Holland. Figure 92 shows one of the central drip-tray type, of which there are four, all similar in every respect. For obvious reasons candlesticks of this general pattern have become widely known as the "Heemskerk" type.

It must be remarked, however, that simply because these pewter examples formed part of a consignment from Holland in the 16th century it does not necessarily follow that they were, perforce, actual productions of that country; there is, indeed, considerable disagreement on this point, and much speculation, even today, on their country of origin.

Figure 91.

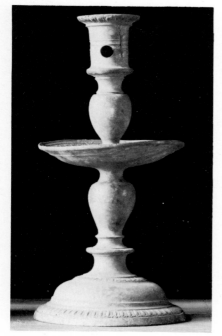

Figure 92.

There are so many similarities between the "Heemskerk" pewter specimens and their brazen counterparts found in England that one must, at least, consider the possibility that the former might originally have been made in England, and then have been exported to Holland in the last quarter of the 16th century.

The writer does not support his view, nor did the late Herr Robert M. Vetter of Vienna, the well-known authority on antique pewterware who, incidentally, was responsible for notifying fellow collectors of this find, and who had the opportunity of examining them carefully. The fact that we have a type which was in common use on both sides of the channel merely follows a trend which was apparent in earlier times, and which continued, with intermissions, for many more years to come.

The central drip-tray type candlesticks found in Nova Zembla, and one other very similar pewter example (shown in figure 93) from the collection of A.J.G. Verster, of The Hague (and now in the Boymans Museum in Rotterdam) are the only 16th century specimens in this metal at present known to exist. In view of the fact that, to date, no pewter example of any period has come to light in England, despite the prevalence of even earlier examples in brass and bronze, the assumption

must be that the type, in the former metal, was not made here. The present writer would need strong evidence, such as a clearly attributable maker's mark on one, to convince him otherwise.

As already stated, although not believed to be the earliest examples, the "Heemskerk" items can be dated positively as of 1596 *or earlier*, and so it becomes a useful exercise to compare its various features with the Verster specimen, to see if any light can be thrown by the comparison which might help in dating that, and any other examples which may be found, whether they be of pewter or brass.

Starting with the foot, the Nova Zembla specimen has two bands of cast lenticular-beaded decoration which, although seen on the bell-based pewter candlesticks from the same hoard (see figure 76 in Chapter 6) are not found on any other specimen of any age, in any metal, and thus it may be assumed that this is an early, purely Dutch, feature and that, in any case, it had but a short reign. (Something not unlike this in appearance, but not effected in the mould, is to be seen on the two brass examples in figure 68.) Note that this cast ornamentation is repeated around the top of the drip-catcher and also on the underside of the everted flange around the top of the socket.

The deep saucer-shaped drip catcher is constant on all early brass examples of this type; in later specimens it takes on a slightly more shallow form. The drip-pan of the Verster example, however, (figure 93) has a distinct additional curve at the edge, which is confined to that particular specimen in pewter and to the two bronze items in figures 99 and 100.

The upper and lower baluster columns, with their distinctive "egg-shaped" knops, are virtually identical in these and the Verster specimen, but marked differences appear in the candle sockets; both have the wide band of reeding at the socket base, but whereas the socket of figure 92 tapers out slightly as it rises (and has a wide flange at the top) the Verster example has a socket which is purely cylindrical. The latter also has a broad convex moulding near to the top of the socket which is not a feature of later types. Because of its general character of heaviness and comparative crudity in relation to the "Heemskerk" specimens, the writer is of the opinion that the Verster example may be the earlier of the two.

We shall return later in this chapter to consider the close links between the Dutch pewter candlesticks and some of the earlier brass and bronze "Heemskerk" types with baluster columns.

Since all the candlesticks referred to hereafter in this chapter are of brass or pale bronze it will, perhaps, be as well to remind readers that any candlestick, of pre-1620 or so, made in a true yellow brass, is probably Continental, and that a bronze candlestick is more likely to be English.

It is proposed to place all of the illustrated central drip-catcher forms into what is believed to be the chronological sequence of their manufacture, starting with the very unusual item at figure 94. This has a foot of a shape identical with that which we have previously found only on the rare group exemplified by the examples in figures 38 and 39, and which we have dated in the first half of the 16th century.

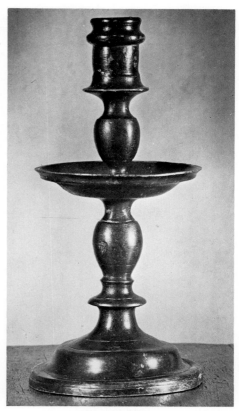

Figure 93.

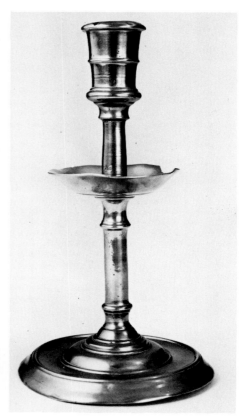

Figure 94.

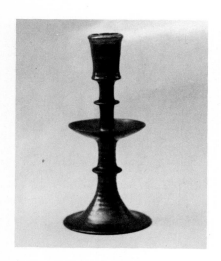

Figure 95.

There seems every justification for including it in the same period, firstly for the reason that the socket is also of exactly similar form, although it has no lateral apertures (which, in itself, might conceivably indicate English origin), and secondly, the column is slim and of approximately the same proportions. In fact, if one were to visualise this piece without its drip-catcher, there would be no significant differences whatsoever.

The whole column in this example, including the drip-catcher, is of one casting, and the foot another; beneath the foot there are very deep rings occasioned by the drastic lathe-trimming to which it has been subjected.

Figure 95 shows an early example of the "ridged trumpet-shaped foot"; this has an unpierced socket, not unlike that on the preceding item, and it is slightly slimmer overall than the few which follow. Figure 96 is another interesting example, for this portrays, for the first time, a patch inserted in the foot for the reason indicated on page 22. Although rigidly held in position, it has become visible only because it has been slightly misplaced in the course of many years of rough handling. This specimen displays clearly the deeply cupped drip-catcher which is so characteristic of the earliest of this group. The foot is beginning to show a downward curve at the base; a feature which, in later examples, gradually develops into a moulded dome.

The example in figure 97 has an unusually deep "mushroom-shaped" drip-cup, and a lower column and base displaying a more advanced stage of the domed foot, although not yet fully developed.

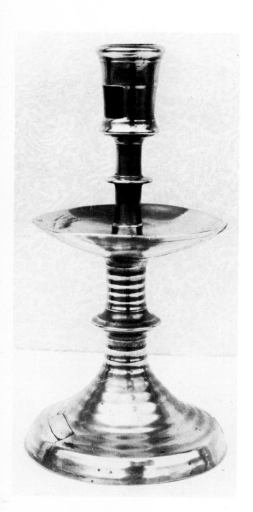

Figure 96.

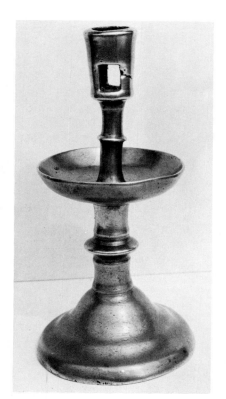

Figure 97.

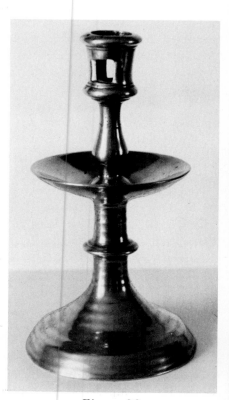

Figure 98.

Figure 98, so far as the base casting is concerned, is a close likeness to figure 96, but introduces a "tear-drop" baluster knop in the upper stem; this is clearly a transitional piece, for the "tear-drop" is soon to be adopted into both upper and lower sections, and, later still, to evolve into the "egg-shaped" knops of the pewter examples. Figures 99-101 show these changes to advantage. It is significant that, at this point, the rectangular apertures in the sockets are discarded in favour of large circular apertures, and in the case of figure 101, no apertures at all. The features to which attention has been drawn are all indicative of the 16th century, and it is considered that a reasonable progression in date may be assumed, from c.1550 for the earliest, to c.1590 for the latest, and thus we can place them all as types preceding the "Heemskerk" pewter examples. Figure 102 shows three further specimens of 16th century, the last of which is closely comparable with figure 92.

In nearly all the foregoing examples, from figure 95 onwards (with the few noted exceptions only), the shape of the drip-tray is steeply cupped, in some appearing as almost a broad inverted cone. This tendency continues into the next few examples up to figure 102, inclusive, and is confined to specimens which have the lower section (i.e., the grease-cup, the lower stem and the foot) composed of a single casting, the upper stem and socket being another single casting, which is joined to the foot by riveting over the end of a long "tongue" which descends through a channel running down the whole length of the base casting (see figure 103). This method of fixture may be taken as indicative of the "Heemskerk" type brass or bronze candlesticks made up to the turn of the 16th century. In later examples they were made in either three or four separate castings, see figure 104.

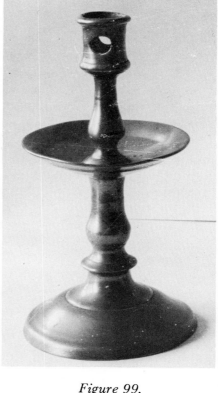

Figure 99.

Figure 100.

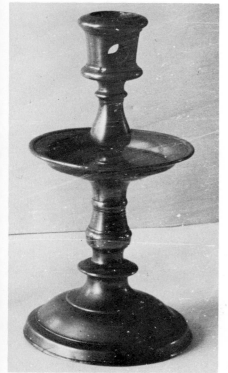

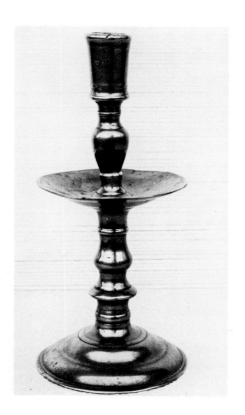

Figure 101.

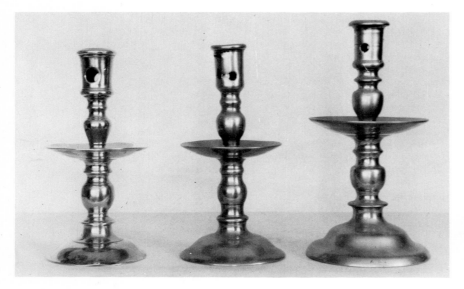

Figure 102.

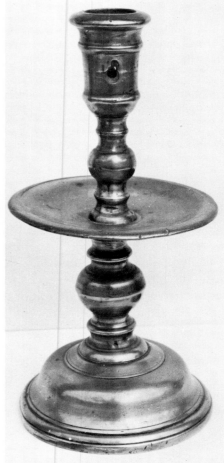

Figure 105.

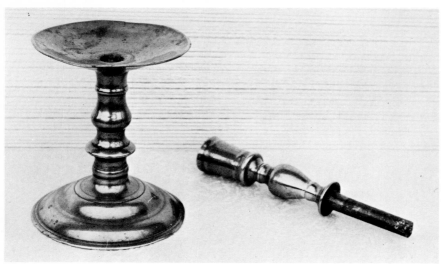

Figure 103.

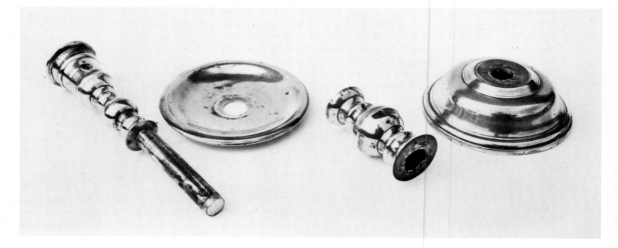

Figure 104.

76

Figures 105 and 106 are representatives of the type which comes next in date. The distinctive feature of these is the "ridged ball" knop, obviously an evolution of the "plain-ball" knop seen in figure 102. The "ridged ball" seems to have been in vogue up to about the middle of the 17th century.

In this group specimens will be found to be of either three or four individual castings, and there would seem to be no means of deciding which was the formerly adopted. All that can be said is that three-piece castings are less frequently found than four-piece. In conjunction with this comes a much shallower, and often much broader, drip-catcher, and, in some, a heavier socket, adorned with several moulded rings of ornamentation. It would seem that, from c.1650, the "ridged-ball" knop began to decline in favour of the "inverted acorn" knop, (seen to good advantage in the group of three specimens in figure 107) and that the latter eventually outmoded it, continuing to be used on the majority of the late 17th and early 18th century examples up to c.1750. These are all of four-piece construction.

Our final illustrations for this chapter, figures 108a and 108b, are of candlesticks with the "tulip-shaped" socket. The first datable illustration known to the author of this type of brass "Heemskerk" candlestick, is to be found in a print entitled "The Brassfounder" in a book by Jan and Kaspar Luiken, of Amsterdam, in 1718. The proof that the "Heemskerk" form was continued for some years is evidenced by the fact that it is shown again — this time by Jan Luiken alone, in 1756, in his *De Kandelaar.*

The "tulip-shaped" socket example in figure 108a has only one small circular lateral aperture, and has been made in the traditional manner, of four separate castings, riveted beneath the foot, but some later examples are of three-piece construction, in which the upper column is screw-threaded at the lower end, and (after insertion through a hole in

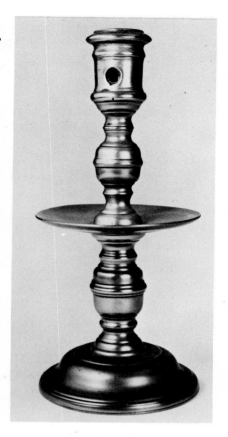

Figure 106.

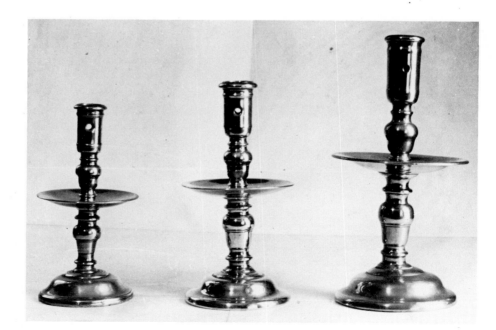

Figure 107.

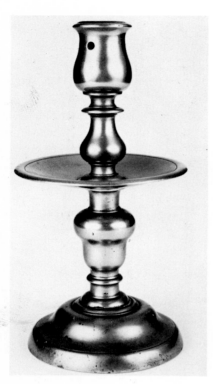

Figure 108a.

the drip-tray) is screwed into a small female-threaded hole in the top of the lower column; the lower column, in these cases, being in one with the broad foot. It is stressed that screw-threads were rarely used on this type, except sometimes in the very late (and in the reproduced) examples; note also that on these there are rarely any lateral apertures to the sockets.

What appears to be an early example of this tulip socketed type, which is particularly unusual in view of its very heavy construction, is to be seen in figure 108b. This specimen is comprised of five separate castings, the top column being virtually identical in form with figure 108a, although the socket is unpierced. It varies, however, from figure 108a, in that it bears a heavy hand cut thread at the base, which thread passes through the drip-catcher and enters its counterpart at the top of the lower "acorn knopped" section. Note that the heavy lower column carries a thinner threaded extension at the base and that this passes through an additional curved section of column before it enters the domed foot. The final fixture is by a crudely cut brass nut on the under-side of the base. The candlestick is shown disassembled in figure 108c.

One might well conjecture why both English and Dutch (and perhaps other) makers followed so closely one particular pattern of candlestick and allowed it to remain in use for something over one hundred years, and the conclusion seems clear that here, for the first time in candlestick history, a really practical form had emerged: (a) it was heavy enough to stand solidly without toppling over; (b) it had a wide drip-catcher at a suitable distance from the socket to trap any overflow of molten wax, and to enable it to be held in the hand without fear of being burned; (c) it had the necessary apertures in the socket to enable candle-stumps to be ejected satisfactorily; and (d) it was a simple process for the maker to join the various separate castings together. Most of these features had been lacking in earlier types of base metal candlesticks, both in England and abroad.

Their very solidity is undoubtedly the reason for the survival of so many examples; it is not unusual to find specimens weighing up to three pounds (avoirdupois) per piece.

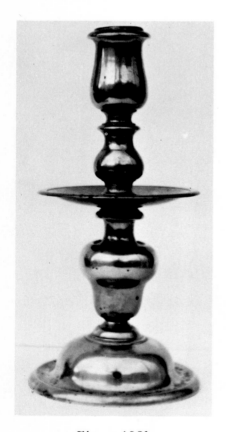

Figure 108b.

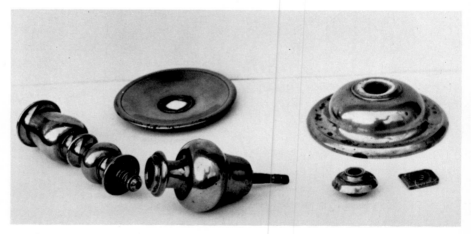

Figure 108c.

8

The English
"Trumpet-based" Candlesticks
in Brass and Pewter

As we saw in the previous chapter, the turn of the 16th century produced one of our most popular groups of candlesticks in brass, known as the "Heemskerk", which remained in favour for over a hundred years in some countries, but for rather less in England. It was about 1630 that a new shape appeared in England, gradually outmoding the "Heemskerk", and, in turn, becoming a stabilised national form for several decades.

Prior to c.1630 the brassfounders had made their candlesticks with either solid, or (when hollow) with very thick, heavy stems, whether they were of plain cylindrical or baluster form; but with the lighter weight, flared "trumpet-shaped" foot, which was soon to appear, came the first hollow cylindrical top column. It would seem that the pewterers were the instigators of the hollow column, for it first appears in a pair of pewter candlesticks (with a base of another type) from Cothele, Cornwall, which can be dated by historical evidence *as not later than 1636.*

Whereas a turned solid baluster column would hold up to rough usage if in a hard metal such as brass, it was unlikely to do so in the softer and more malleable pewter; and so the hollow cylinder was devised and adopted to suit the material in which it was first used, but it also enabled the candlesticks to be made of much less metal, and consequently much lighter in weight, than formerly. This fact was soon realised by the brass workers who, in the 1640 s, made the first hollow, cylindrical-stemmed brass candlesticks in the same form as the pewterers.

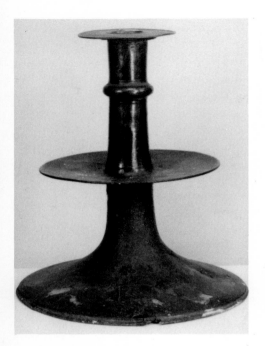

Figure 109.

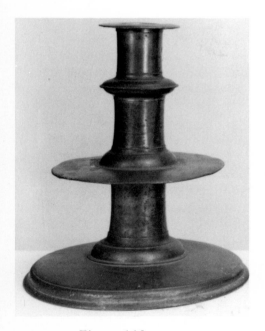

Figure 110.

1 See Jackson's *History of English Plate.*

The foot, from the spreading base to the "waist" (i.e. to the point where the drip-tray would normally sit) is almost exactly in the form of a musical trumpet, hence the name given to this type by collectors. Above this flared foot was placed a wide, slightly cupped, circular drip-tray, of somewhat the same form as that which had adorned candlesticks of the "Heemskerk" type. What might be termed an "embryo example" of this base is to be seen on the example in figure 95, in the previous chapter.

It is possible to date this general type from comparable designs in silver,[1] but one cannot find any reliable evidence as to its longevity; it must be assumed, however, that so far as pewter is concerned it remained in use for no more than twenty or thirty years, but that it continued longer in brass, for no other brass styles (except the "Heemskerk") predominate until towards the end of the century. The pewterers were more susceptible than the brass-workers to changes in fashion and were more inclined to follow the styles evolved by the silversmiths; as a result we find a multitude of variations in pewter candlesticks throughout the rest of the 17th century — more so, in fact, than in any other fifty year period.

The earliest examples of the trumpet-based form are undoubtedly those in pewter, shown in figures 109 and 110. The first specimen is one of a pair still *in situ* in the chapel at Cothele, Cornwall, the longstanding home of the celebrated Mount Edgcumbe family; the second item, also originally from Cothele, was sold when the residence passed to the National Trust.

The large convex band of reeding on the upper column of the latter was, obviously, to serve the dual purpose of strengthening the column against crushing, and to give a good purchase point for lifting; this feature, in its more prominent form, soon disappeared, but remained as a very slight ridged moulding, in the same position on the column, for a few more years (as seen in figure 109). In time, however, it was found that this restricted ridging was insufficient to prevent crushing of the stem (a fact that is apparent in the stems of one of the examples illustrated in figure 111 and in figure 113). It was only a short step onwards for the column to be deeply corrugated throughout its length, and this feature remained constant for the majority of brass examples.

A somewhat wider, but less pronounced, series of corrugations (or ridging) was adopted by the pewterers, and this predominates in most pewter trumpet-based (and succeeding) types to the end of the century.

In some of the earlier examples of this type in pewter, figure 109 included, the columns are hollow throughout the whole length of the stem, and still open beneath the trumpet foot, and so a candlestick could be retained in the socket only while it remained a tight fit, but as it burned low the heat generated from it would reduce the circumference of the candle, and it could sink inside the column.

To obviate this happening the candlesticks were fitted with a separate sconce, in the form of a "Welsh hat". This loose sconce was merely dropped into position, and could, of course, be removed as required. In figure 124, in the next chapter, one such sconce has been left off to show this feature clearly. The wide top flange, seen on the pewter

example in figure 109 is of separate "Welsh hat" form, and removable. It would seem that the makers had not, at this early date (1635-40) been able to devise a suitable casting incorporating a "stopper" within the column itself.

In the pewter example of slightly later date, shown at the top of figure 111, the socket flange is an integral part of the column, and the candle is prevented from slipping inwards by a disc of metal, swaged into position about one and three-quarter inches down from the top (see drawing, figure 112a). The trumpet-shaped base, and the column, are hollow right through to this point, and if one were to look upwards from within, the thickened "collar" (c) may be seen on the underside of the "stopper"; this collar has a screw-thread in the centre. In the drawing it will be seen how this screw-thread serves a specific purpose in the final trimming and polishing of the candlestick, for the completed 'stick was held firmly during the process by being screwed on to the rod (b), which, in turn, was held in the lathe-chuck (a). This method was used by the pewterers on the majority of their candlesticks which have hollow columns, throughout the rest of the 17th century (i.e., on practically all those in the following chapter); the incidence of the screw-thread visible inside the column being an almost infallible proof of the genuineness of the candlestick, and of its English origin.

The method of "stopping up" the columns in brass specimens was far less complicated, simply because the columns were not hollow throughout, but were cast in two sections, riveted together, as shown in the sketch (figure 112b).

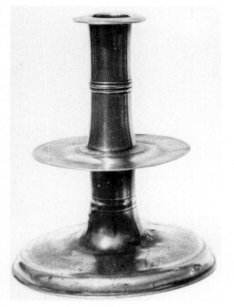

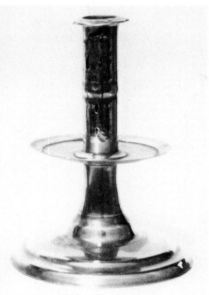

Figure 111.

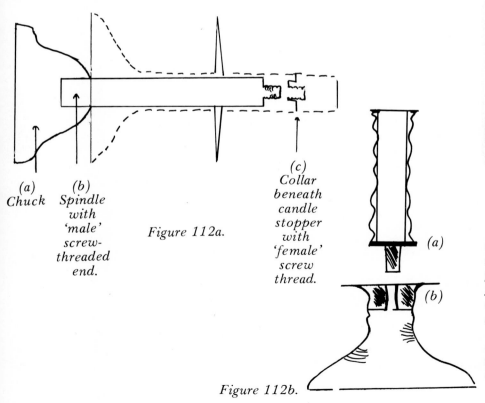

(a)
Chuck

(b)
Spindle with 'male' screw-threaded end.

Figure 112a.

(c)
Collar beneath candle stopper with 'female' screw thread.

(a)

(b)

Figure 112b.

The top column (a) is hollow from the top downwards, having a solid stop at the base with a projecting tang below; this merely fitted into a hole in the lower casting (b) which was very much strengthened by an internal 'collar' at this point. The marriage of the two parts was made by riveting over a slight projection of the tang.

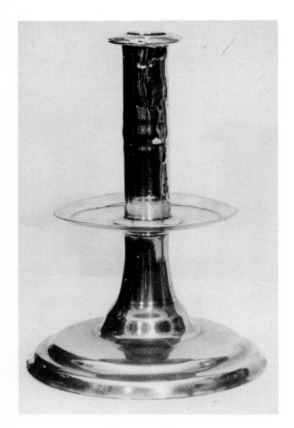

Figure 113.

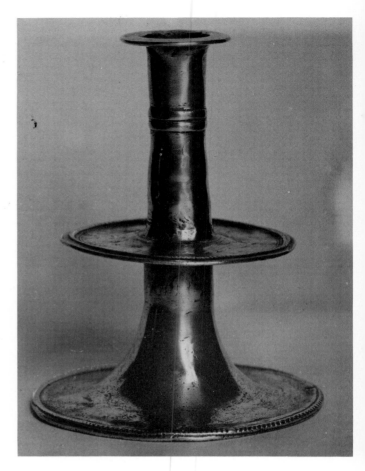

Figure 114.

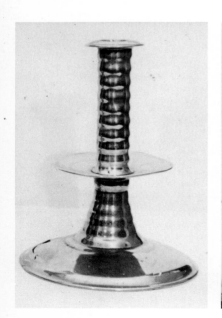

Figure 115.

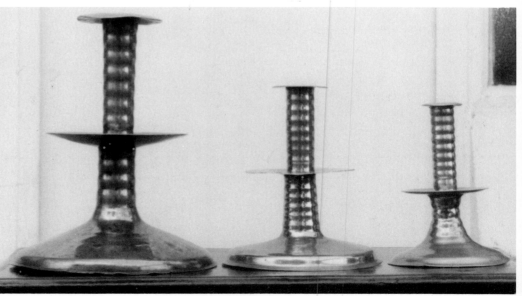

Figure 116.

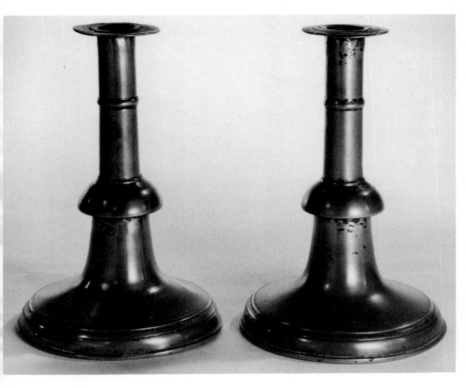

Figure 117.

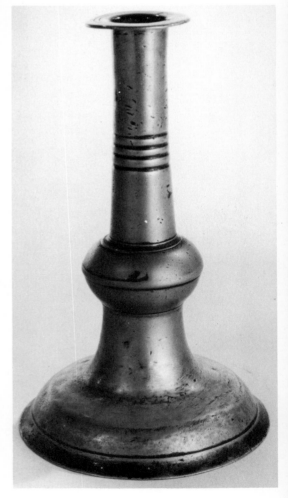

It is an unusual occurrence to find a maker's mark on brass candlesticks of this form, but very occasionally some traces of such a mark have been found struck upon the upper side of the wide drip-catcher; mainly these marks have become so worn by continual wear that only the faintest depressions remain where once they were struck. In one case only a clear mark, of ◆ on a candlestick of c.1650 has been recorded, but, of course, no suggestion can be made of the name of the maker.

The photographic illustrations from figure 109 to figure 122 show a progression of variations of trumpet-based candlesticks, in both pewter and brass, from c.1635 to c.1675; those in figures 117 and 118 being of particular interest inasmuch as they display a late, and abortive, attempt at a departure from the drip-tray proper, the hollow "ball-knop" obviously serving a very useful function as a grip for lifting or carrying the piece, but almost completely useless as a hindrance to falling candle-grease. It is notable, however, that with this form there came a wider flange at the top of the socket.

In due course, and no doubt as a result of foreign influences arising from the installation of a Dutch monarch on the English throne, a new feature was introduced in the form of the raised, square base (with corners lopped off), a feature already well known elsewhere. This completely changed the character of the trumpet-based candlesticks (see figure 119). This form of base will be seen, in later years, completely to transform all other types of English candlesticks. In Chapter 9 we shall see how it affected the "flowered base" pewter candlesticks, and, in Chapter 11, how it came to dominate the styles in vogue for the first decade of the 18th century.

Figure 118.

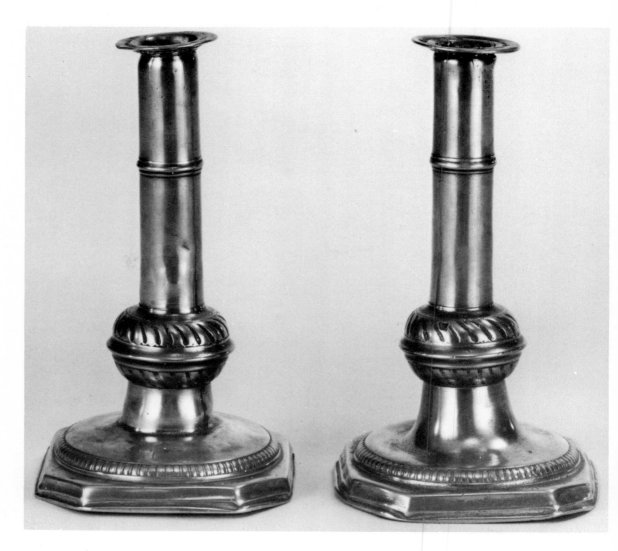

Figure 119.

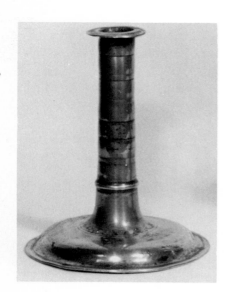

Figure 120.

Figure 120 is a rare trumpet-based example, having no drip-catcher at all, nor any device to act in its stead, and it is probable that only a few were made in this form at a time when experiments in the improvement of wax candles led the makers to believe that a wax-retarding feature could be dispensed with.

The two examples which follow, one in brass and the other in pewter, figures 121 and 122, are somewhat later in date; both believed to date around the turn of the century; they do, however, by virtue of their lack of grease-tray, enable one to see clearly the contour so characteristic of the true trumpet base; i.e. that the diameter of the rising centre of the flared base is identical with that of the cylindrical column above, giving a continuous lateral symmetry. It is this characteristic which distinguishes the true "trumpet-based" types from the "flowered-base" examples which follow in the next chapter. The accompanying drawings show clearly how, in the latter, the diameter of the upward curve of the base is greater than that of the column above.

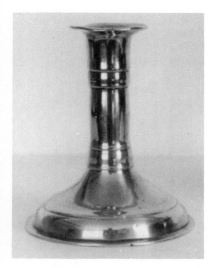

Figure 121.

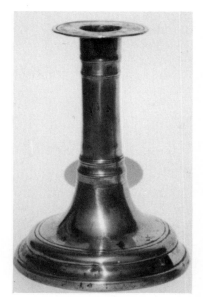

Figure 122.

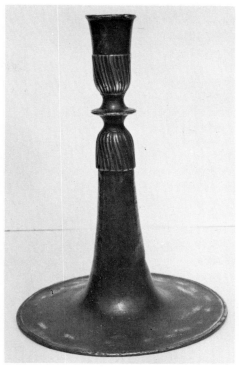

Figure 123a.

Figure 123b.

An unusual example of a trumpet-based candlestick is depicted at figure 123a. It is of pewter, with a fine flattish circular base rising steeply to a slim, plain, conical stem and, up to that point, is closely comparable with the normal English trumpet-based specimens shown in the preceding illustrations. Above the plain stem, however, appear features which are difficult to correlate with this form, but of which exact counterparts are to be found on a pair of somewhat similar examples, also in pewter, illustrated by Hugo Schneider in the catalogues of pewter in the Swiss National Museum.

The raised slightly writhen mouldings, both below and above the bladed knop, which extend to the plain top of the socket, seem to be out of character with its other features, but there can be little doubt that it is of early production and datable, probably, somewhere in the first quarter of the 18th century.

A feature to which particular attention must be drawn is its method of construction; the column is hollow throughout its length right up to a point within the area of the bladed knop, at which point is found the "female" screw-thread, to which reference has already been made. It has hitherto been considered almost an English "national trait."

In this particular case, however, no claim to English provenance is made, for Schneider attributes the Swiss specimens, with only slight reservations, to the Canton of Zug, an area which appears to have had a long reign as a candlestick producing district, if one may judge from the number of Zug moulds in the Museum.

Aesthetically, it would seem reasonable to suggest that this candlestick might, originally, have been accompanied by a wide-flanged additional socket of "Welsh hat" form, as can be seen in figure 123b (the loose socket was not in company with it when it was purchased in England).

9

The Wide "Flowered" Base – Mainly in Pewter

From about 1635, and (in its earlier years only) coeval with the trumpet-based specimens dealt with in the foregoing chapter, a somewhat similar, but more elaborate, form of hollow-cylindrical stemmed candlestick emerged. It differed from the trumpet-based, originally only in the shape of the foot itself; a glance at the drawings at the end of the previous chapter will illustrate the difference.

It is not possible to say precisely why the base column diameter should exceed that of the top column, but one may hazard the suggestion that it was designed to give the drip-tray some added support; certainly, pewter, owing to its malleability, would need some such strengthening.

This foot style seems to have developed around the turn of the 16th-17th centuries, and a close likeness to it, though not quite so wide at the base, appears on one of the two types of pewter candlesticks from the Heemskerk expedition. Its marriage to the hollow cylindrical stem, however, was a later development, as stated. The specimens which we can use as a chronological "peg" are the Edgcumbe candlesticks, shown in figure 124; these are of pewter, and can be dated to 1636 *or earlier*, since they bear the engraved heraldic arms (in lozenge) of Mary Glanville, a spinster who married Piers Edgcumbe, son of Sir Richard Edgcumbe, in that year.

There is a set of four pewter candlesticks at York Minster, one of which is shown in figure 125, of this same general type, and there is little doubt that they can be dated very closely, although the Minster records contain no mention of their purchase or presentation.

The separate sconces, which are a feature of both the Edgcumbe and York Minster specimens, are referred to in the preceding chapter; another feature common to both is the cast "rope" or "cord" mouldings at the edges of the foot and drip-tray. This "rope" decoration appears only rarely on specimens made after about 1660.

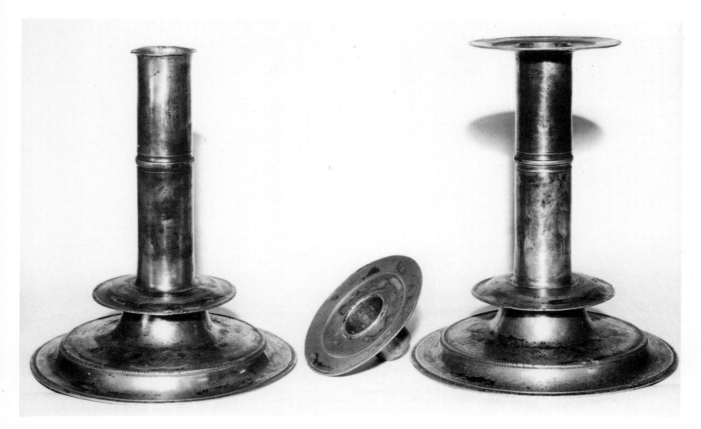

Figure 124.

The description given in 1649, by Randle Holme, one of several generations of historians of this name, who left numerous manuscript records (now in the British Museum), indicates that he was familiar with candlesticks of this identical form, and others which will be described in the following pages. He described the common candlestick with socket as:— "... the design decorated by raised work, corded or twist work. The bottom and flower part (flared foot) could be round, square, hexagonal, octagonal, and chased".

He named the parts of a candlestick as:— "... the socket where the candle is set; the nose (nozzle) is the length from the socket to the round rim or broad brim set in the middle of the 'stick on which the tallow drops; the buttons or knops are those outswelling works made on the shank or neck of the 'stick to adorne it; the bottom is all the remaining part of the 'stick, from the flower upon which it stands; the edge, or cord, or flourish round the bottom. There are save-alls, or prolongers, made in the shape of a candlesocket, and (these) are set in the stick".

With candlesticks of the form shown in our first illustrations is established the style of the foot and waist-high drip-tray which features in the majority of English pewter candlesticks up to the end of the century, although just prior to 1650 the foot flange, circular in the earliest examples, takes on an octagonal shape, and gradually this shape came to be used on the socket flange, and last of all, the drip-tray was given an octagonal edge. Each one of these features, showing the gradual

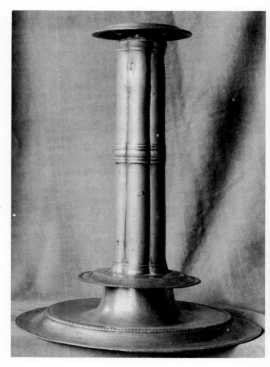

Figure 125.

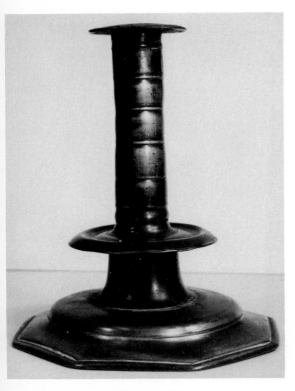

Figure 126.

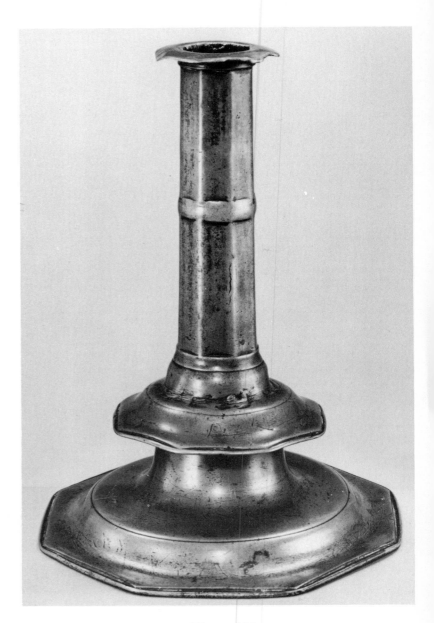

Figure 128.

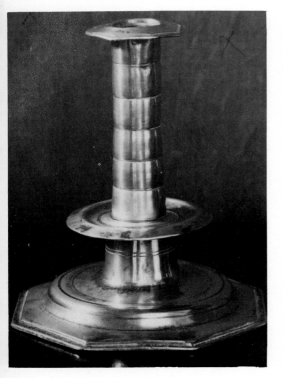

Figure 127.

development from the all-circular, to the all-octagonal, is apparent in the evolutional sequence of specimens shown here; for example, in figures 124 and 125 these are all-circular; in figure 126 only the foot is octagonal; in figure 127 the foot and socket are octagonal, and in figure 128 all three are octagonal, and from henceforth this becomes the normal practice (with a few rare exceptions, of which the specimen in figure 131 is one, although, even then, the features are all uniform in shape).

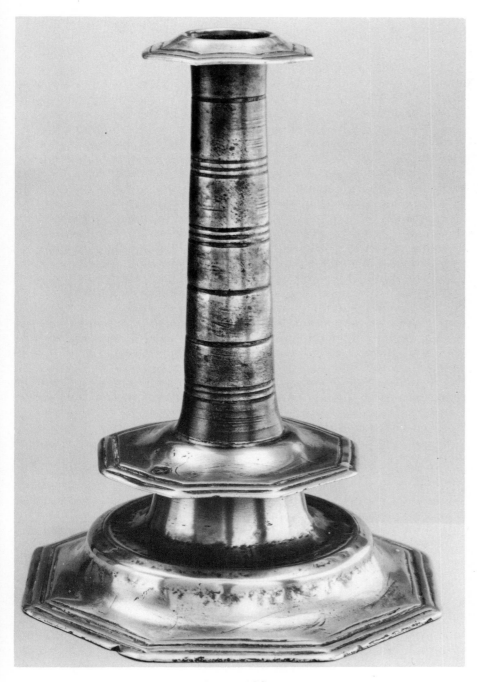

Figure 129.

Note that in figures 126 and 127 the columns have wide corrugations covering the length of the stem, and it will be found that this form of strengthening is the more frequently used throughout this group, but not to the exclusion of other modes; a rare example, with octagonal stem, is shown at figure 128.

Figures 129 and 130 illustrate other variations in column ornamentation. An exceedingly rare, perhaps unique, item is shown in figure 131 in which the base, the drip-tray and the socket flange are "scalloped", but still maintaining the octagonal sequence.

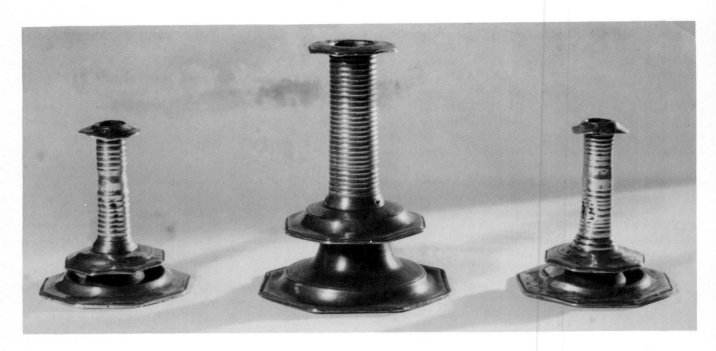

Figure 130.

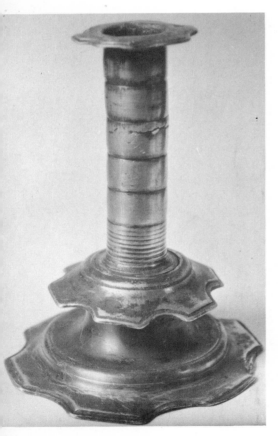

Figure 131.

The examples illustrated may all be placed within the period c.1660-75, and it is about the beginning of the last quarter of this century that a new feature appears, in the form of a relief-cast ornamentation around the raised edge of the foot, (see figure 132). In some, this is a running design of grapes and vine; in others it appears to represent a floral garland, interspersed with either marigolds or small Tudor roses. A few examples have been seen with a *fleur-de-lis* motif repeated. This type of ornamentation, in one form or another, remained a constant feature on some pewter candlesticks for about ten years only, but not to the exclusion of the plain base. We have now reached a point where the hollow cylindrical column was beginning to lose favour, and to be superseded by a more florid baluster column which seems to have been introduced from Scandinavia; this later column displays a large, hollow knop in centre, with narrow turned mouldings above and below it. The candle-socket is also adorned with bands of ovolo mouldings, quite un-English in character, but there can be little doubt that the form became popular here, for the writer is aware of about a dozen specimens, the majority of which he would have no hesitation in calling English, but of the others he would be less sure. Figures 133 and 134 show representative examples; the first with a plain foot and circular drip-catcher, and the second with relief-cast ornamentation around the foot, and octagonal drip-catcher, both of c.1680-90.

It is from Scandinavia also, that another, entirely different, type of candlestick had emerged a few decades earlier. These were the large table candlesticks, made entirely of thin sheet-brass, hammered into shape, and with the sections brazed together. These were adorned with intricate relief floral and fruit motifs around the domed bases, and on the wide flanges of loose sconces.

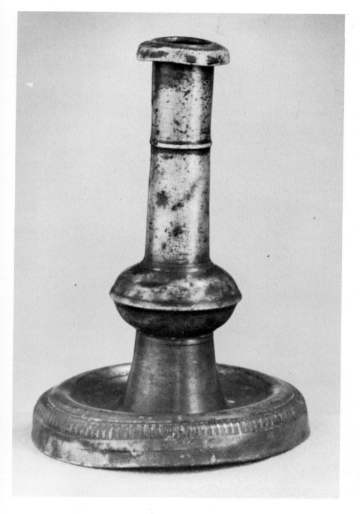

Figure 132.

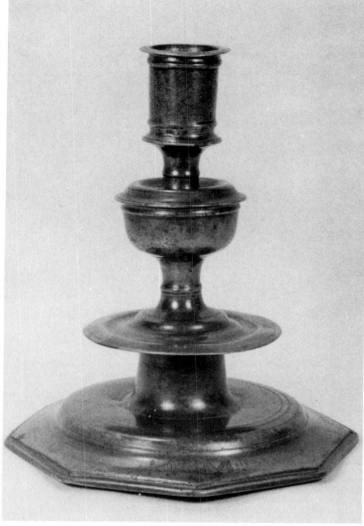

Figure 133.

The shape of the bases conforms closely to all others in this "flowered base" group, but the columns are usually spirally ornamented throughout their length. Somewhat similar candlesticks, made in Holland, in both brass and silver, were produced in the 17th century, and in many instances it is not always easy to judge their origin. Hammered brass items, including candle boxes, chamber candlesticks, dishes, nut-roasters, warming-pans and lanterns were made in profusion, in both Norway and Sweden from the mid-16th century onwards.

Not all the candlestick types we find in the 17th century can be fitted into neat stylistic groups, although on practically every example there can be found some feature which is an essential characteristic of more well-known types. For example, the unusual model shown in figure 135, one of a pair, in pewter, is rare, and one might have encountered some difficulty in fixing a date closely. It bears the touchmark of one Hugh Quick, of London, who is known to have worked in the period 1674 to 1708 (his touch bears the former date, in which year he was granted his

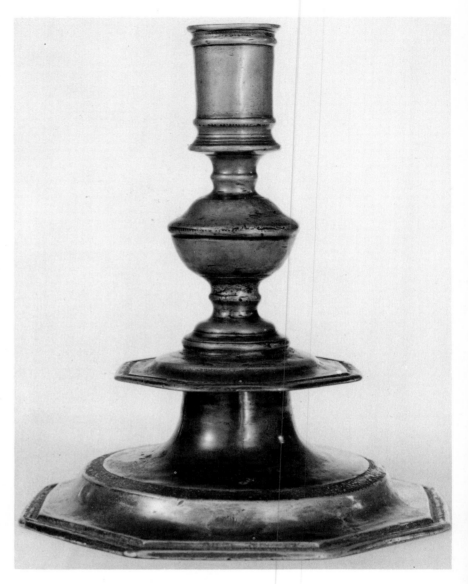

Figure 134.

"freedom"). Thus, the pieces might have been made at any time during his working life, but by good fortune, we have been able to find candlesticks of almost this identical form in silver. Figure 136 illustrates one of these fine silver candlesticks, 13¾ inches high, from Harthill Church in Yorkshire. It seems likely that they might well have been the prototypes for the pewter examples, for they bear the silver marks for 1675, and this would certainly ante-date the pewter specimens by a few years; one cannot expect that such fine examples of the pewterers' craft would have been produced in the first year or so of a pewterer's entrance into the trade. A date of c.1680 is set upon the pewter examples. These pewter 'sticks are, in their present state, 9⅛ inches high, with a foot diameter of 7⅞ inches, but the base has been depressed by about ¾ inch or 1 inch, and the original overall height would have been nearer 10

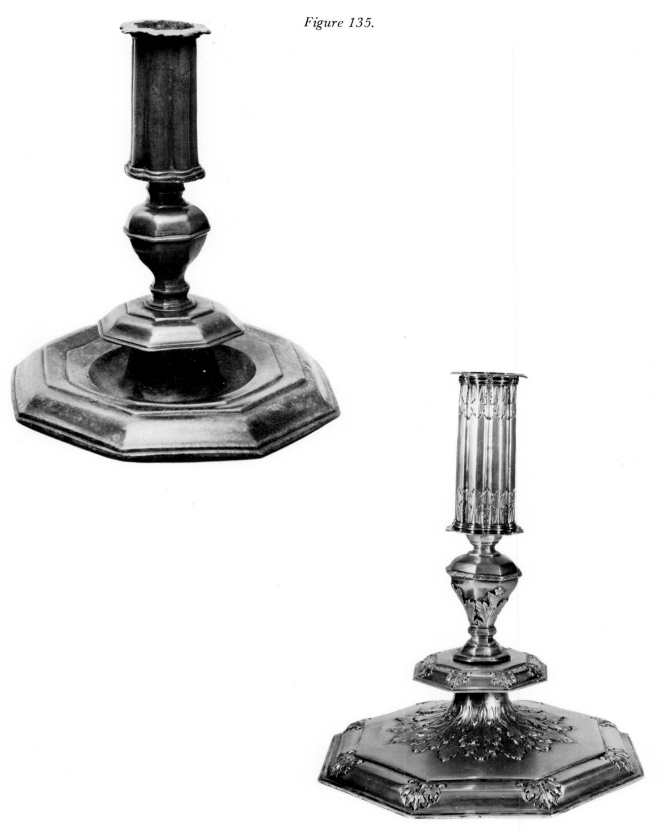

Figure 135.

Figure 136.

inches, and thus they would appear to be even closer counterparts of the silver specimens. In both pewter and silver, the centre knop is octagonal, to conform to the shape of the features below it, but the tall sockets are "lobed" in both cases; the socket flange in each is "fretted" at the edge — all extremely rare features.

The writer, with over thirty years' experience of old candlesticks, had failed to find a comparable example in brass or bronze until perusal of J.R. Grove's book, published in 1967, in which a fine pair, in brass, 8¼ inches high, are shown, and permission was granted for them to be reproduced here, figure 137. In these the base and the centre knop are hexagonal, and the tall sockets are not lobed, but equilaterally hexagonal — a rare feature. They are judged to be English, of c.1675-80.

We are nearing the end of the 17th century, and the decline of the wide "flowered" base with low drip-catcher above the foot, but one or two examples retain some of these features whilst they also incorporate others which are to become standard characteristics of candlesticks produced in the late William III and early Queen Anne period. The pewter candlestick in figure 138, for example, although it retains a cylindrical column and drip-catcher, has an additional means of wax collection incorporated around the foot. A depression of this character is very frequently incorporated in later examples, after the upper drip-tray had been abandoned. In figure 138, and in our final example, figure 139, the shape of the foot has changed to a "square with sliced corners"; this is another feature we shall find in conjunction with early 18th century baluster columns in Chapter 11.

It is proposed to break the chain of evolution we have tried to maintain to this point, and in Chapter 10 to deal with an isolated group of candlesticks which does not seem to link in comfortably anywhere else.

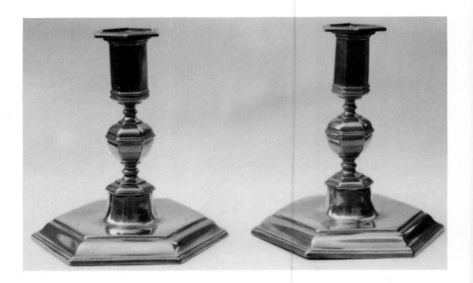

Figure 137.

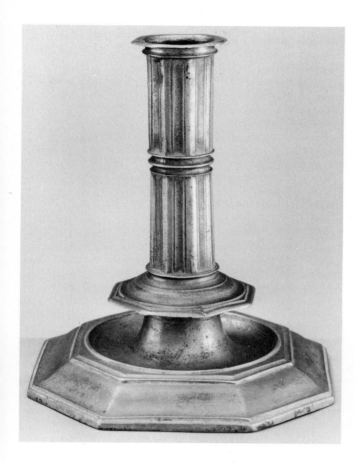

Figure 138.

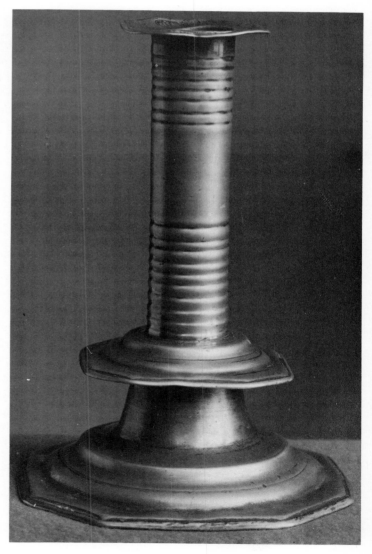

Figure 139.

10

The Latin Group–
c.1600 to the Early 18th Century

The wide variety of forms we propose to consider in this chapter have little in common with those which have gone before, nor, in fact, with those we shall find in subsequent chapters; they form, in themselves, a close-knit "family" in which almost any one of the members seems to have some feature, or multiplicity of features, which can be found in one or more of the others. It may be merely a similarity in the form of the socket of one to that of another which, otherwise, has quite a different stem or foot; on others it may be some likeness in the method used to fix the stem to the base, or how the pieces are finished on the underside of the foot, or, again, in the quality of the alloy from which it was cast.

Whatever the similarities or differences may be, they indicate several things quite clearly; firstly, that to allot these specimens to any specific provenance would be a virtual impossibility. We know that examples of many of these forms have been found in large numbers in both Spain and Portugal, and we have every reason to believe that they had been in use in those countries in particular, and, in some cases, for several hundred years; nevertheless, this does not necessarily imply that they were local products. Secondly, it would be pedantic to attempt to place them in any precise chronological order; certain features are accepted as broad guides to date, such as the incidence of circular apertures in the sockets of some, which are unlikely to have been used before 1600, and would not normally have continued in use much after 1700, but against this we have some others of exactly similar form which have no lateral apertures at all. Similarly, we shall find other features arising in these which are quite out of character with the dates that would otherwise have been set on them. Such anomalies could, perhaps, indicate that a particular form had remained in use for a considerable period of time, and that the feature we have selected as being significant is an unreliable guide in the areas in which these pieces were produced; this has already been exemplified in relation to the large rectangular apertures in the sockets of some 17th century conical-based specimens.

If we accept the possibility that the majority are products of small workshops in remote areas of Spain or Portugal, it is reasonable to assume that the makers were unaware of the rapid changes in form and fashion in more advanced centres. It is obvious that large quantities were produced, and that there were, probably, numerous workshops engaged in their manufacture, to such an extent that imports were unnecessary. Such a large usage would be compatible with a strong Catholic community, to hold the myriads of candles burned in their devotions, both in the churches and in their homes.

We can take as our guides only those features which we are reasonably sure are reliable, and hope that, in the course of time, collectors knowledgeable in the antiquities and products of their own countries will be stirred to publish the fruits of their own studies.

For our first illustration (figure 140) we have chosen two specimens, one in pewter and the other in pale bronze. The significant points of similarity are, (i) the long cylindrical sockets, (ii) the lack of lateral apertures in the sockets, and (iii) the thick bases of hexagonal shape with slightly raised circular areas, and only shallow depressions in the centre to catch the overflow of molten wax.

The contour of the underside of both follows that of the upper surface, as drawn in figure 141a.

A base of octagonal shape appears on the centre specimen in figure 142, whereas those at left and right are square; the bases of all are just as heavily cast as those in our first illustration, but the outer edge of the foot is not solid, as it might appear, but is raised on a slight "skirt"; also, there is a prominent ring around the base of the column, encircling a deeper and more pronounced wax collection area; the contour of this, too, may be seen in figure 141b.

Figure 141a.

Figure 141b.

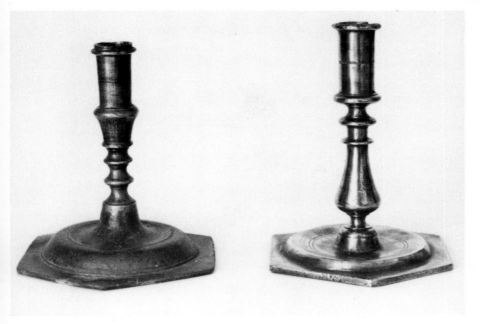

Figure 140.

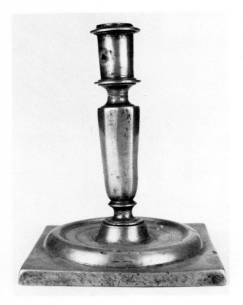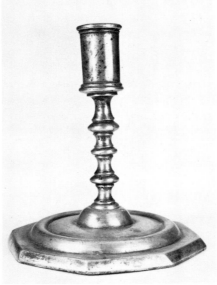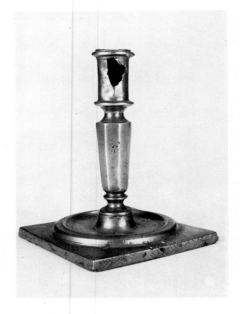

Figure 142.

Figure 143 (detail).

The octagonal based specimen has no lateral apertures in the socket, but those alongside each have one small circular aperture only. All three are cast in pale bronze.

Figure 143 is of two further examples, this time, in a soft, coppery-bronze alloy; the first has an octagonal base constructed on the same principle as those immediately above, and the socket without apertures. The example on the right has a heavy, square base with "skirt", the four corners of which have been extended to form bracket feet. This example is somewhat better finished on the underside, which shows faint furrows left by the trimming lathe. Also on the underside, at one corner, is a maker's mark, of a scallop shell (figure 143 detail), evidently impressed in the mould and thus showing in relief on the finished article. This is an interesting feature, but unfortunately we have no records to indicate where, or by whom, it was made. It has one large aperture, low in the socket.

A provisional date of c.1600 has been placed upon those in figure 140, and of c.1600-50 on the others.

Those in figure 144 cannot be very much later than the two square-based examples in figure 142, for the columns are of identical form, and the sockets also have only one aperture in the side; they are, however, set upon very different types of base. Those of the two at left and right have the large flat base trimmed to almost card thinness; it gains strength only from the thickened sections at the edge, triangular on these, and rounded on some others which follow. The base of the centre item is of quite different character, such as is rarely found on candlesticks of this "family". No lateral apertures appear in the socket.

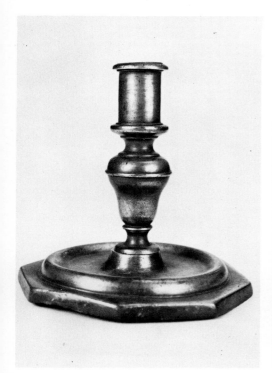
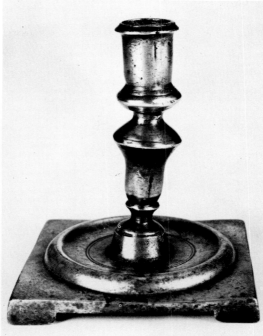

Figure 143.

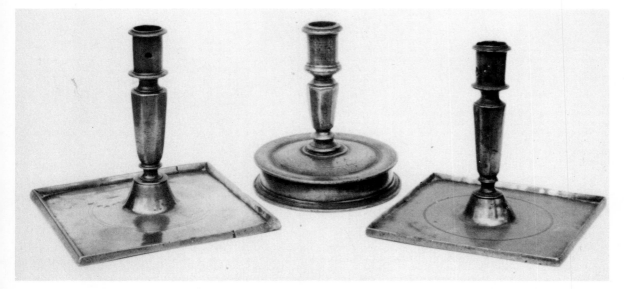

Figure 144.

The flat "tray-base" appears again in the two examples in figure 145, this time, however, with multi-knopped column, and unpierced sockets. In the second example, with circular base, the socket is elongated, as in those in figure 140. All the foregoing specimens (with the exception only of the first item in figure 143) have columns of solid metal.

In the following illustrations several other features are noted. In each of these examples the stems are cast hollow, by the method explained in Chapter 6; somewhere on the bulbous knop it is possible to find the

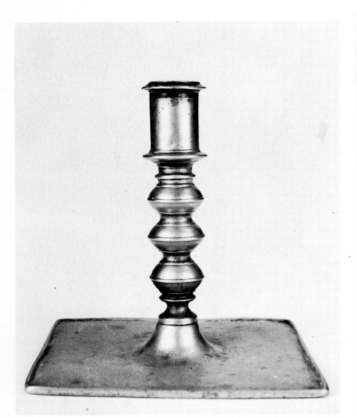
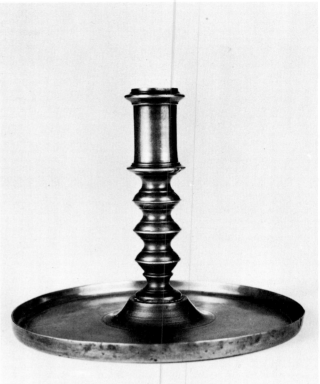

Figure 145.

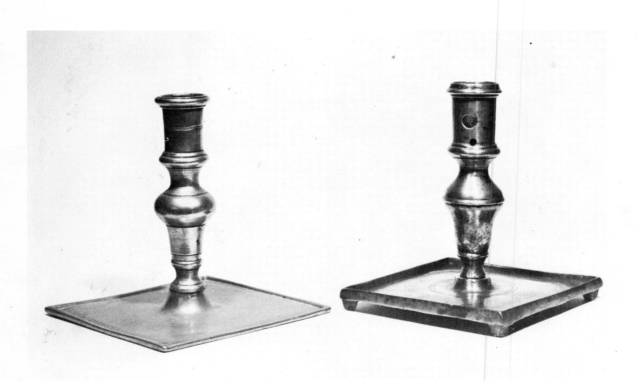

Figure 146.

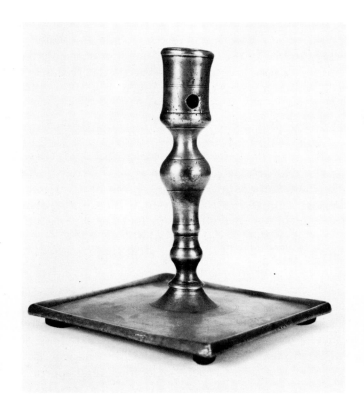

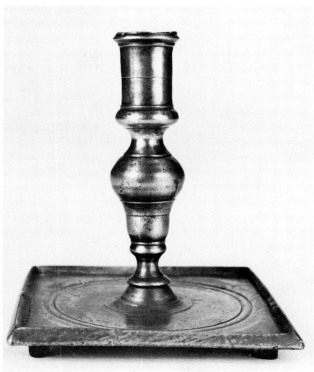

Figure 147.

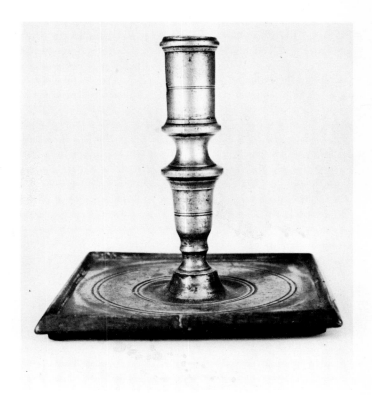

small iron or bronze "pin" which has held a clay core during the casting process, and we had formerly considered this to be a practice adopted around the turn of the 16th century! Herein lies one of the anomalies to which attention has already been drawn, for it seems inconceivable that so many examples, of so frail construction so far as the flat base is concerned, can have existed intact, if of the age implied.

The wide, square flat base is continued, but another feature is incorporated. In the second example in figure 146, small feet will be observed beneath the four corners; these are of triangular section and have been cast integrally with the base. In figure 147 the feet are still there, but have been set back about a quarter inch from the edge, and so do not show clearly in the photograph. The bases, in all other respects, are of the same character as those at left and right of figure 144, and it would seem reasonable to assume that those with feet are slightly later, since the footed specimens are continued into the early 18th century, as shown in figure 148. These are an obvious evolution of the types we have already considered; note that the character of the base has not changed materially, but it has acquired a decided cone in the centre and the feet themselves have become more sophisticated.

The stems of the examples at left and right are hollow, effected by clay coring, the specimen on the right being possibly the earlier of the two, in view of its less ornate feet. It has the shapely "pear-shaped" knop we found on two examples in figure 147, but lacks the lateral apertures. That on the left has a column closely comparable with that on the last item in figure 147 and has one small aperture in the socket. Both are placed in the period c.1690-1710. The tall centre item is of very much more sophisticated form, especially in the wide flange which adorns the top of the socket, and on this feature alone we must put a date in the first quarter of the 18th century.

The stems of all the brass and bronze specimens in figures 142 to 148 inclusive, have been screw-threaded into the bases.

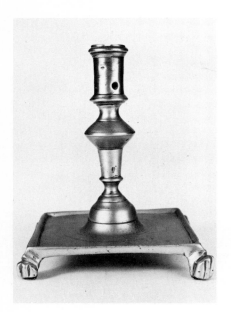 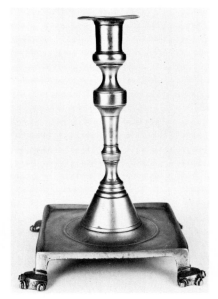 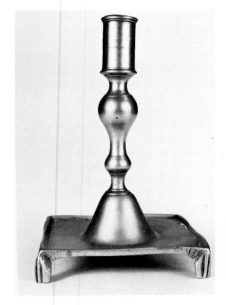

Figure 148.

This seems to be an appropriate point at which to introduce the tall, solid-stemmed examples in figure 149; the first of these has a column closely comparable with that on the centre item in the foregoing illustration, and a somewhat similarly shaped socket, also with everted flange top, but there the resemblance ends. The column has a screw-thread at the lower end which holds a separate deeply-cupped drip-catcher in position above the heavily cast foot. It is 11 inches high, and it weighs 3¾ pounds; a truly magnificent specimen, in excellent quality brass. Its date is quite possibly in the first decade of the 18th century, although some of its features might lead one to consider it earlier. The four small bracket feet are incut by about an eighth of an inch beneath the skirt of the square, moulded base, which is hollow on the underside. There is a base of very similar character on the second item, although, in this case, the feet are merely an extension of the skirt itself. This, too, is a heavy specimen, weighing 2¾ pounds in a good quality golden coloured alloy, probably bronze. This example is placed quite confidently in the early 18th century.

Figure 150 shows three examples, each with a distinctive broad, hollow domed foot, so broad that one might be tempted to consider that they were so made for safe use on board ship, but this would be pure conjecture. We have already seen the large, flat, square bases which

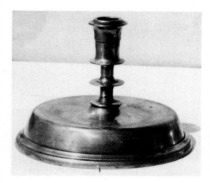

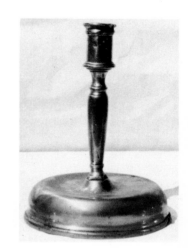

Figure 149.

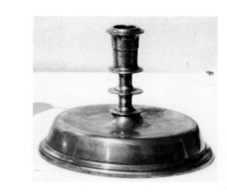

Figure 150.

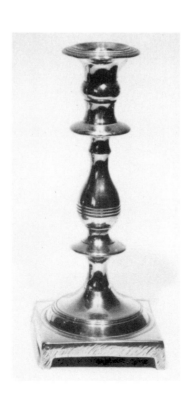

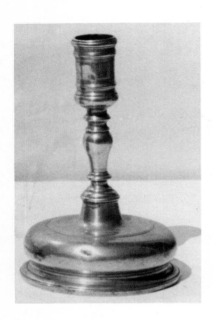

Figure 151.

rendered some other specimens practically "unspillable", and we have no real grounds for allotting to them any special purpose to account for it. In these pieces we see, in the shorter specimens, sockets which taper outwards, with no lateral apertures, and cylindrical stems below, enriched with a wide, bladed knop in the centre. These stems are riveted to the bases. There is some similarity in the stems of these to the specimens in figure 65, and this could well indicate a common origin, although it seems appropriate to place the large, broad, domed base of the shorter specimens late in the first quarter of the 18th century. A point to note, which indicates a Spanish origin, is that the side flange of the broad base splays outwards, whereas that in the centre does not splay outwards at the edge, but curves inwards, as does that on the Dutch items from the Dutch merchant ship "Amsterdam", which foundered off the beach at Hastings, Sussex, in 1749. One may observe some likeness in the column of the centre example to those on the candlesticks in figures 38 and 39, and another in the incidence of the squared lower knop. Note, too, that the column is of square section at the point where it enters the base. This has been fixed by spreading the square "tongue" outwards by splitting the end crosswise, and then hammering it to rivet the "tongue" in successfully. This rather less broad domed base is found on quite a number of candlesticks with "pear-knopped" stems of the types seen in figure 147 (first two items), and with a stem with very bulbous knop.

Continuing with a domed foot we have the example in figure 151 which is of good quality brass, although, in this case, we can be reasonably sure of a Dutch origin, for several closely similar specimens have come to light recently during the diving operations around the "Amsterdam".

The socket is now without apertures, although it is interesting to note that, originally, a single aperture had been drilled, and was later filled in (by the maker) before the lathe turning was done. This is evident from a

Figure 152.

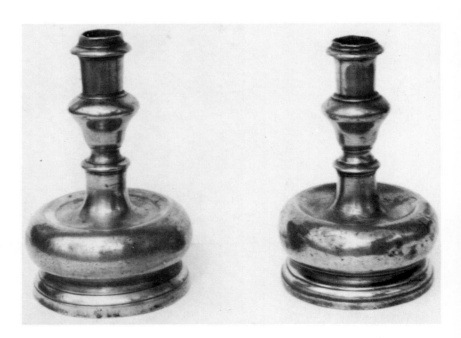

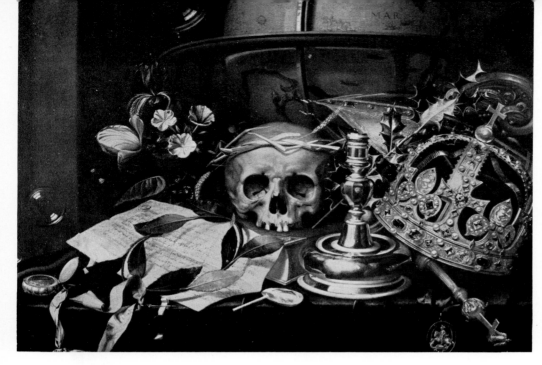

Figure 153.

band of incised reeding which encircles the socket and happens to run right through the inserted section. The column is of solid metal, and is riveted on the underside of the hollow base.

All the above broad, hollow bases could have evolved from a far more well-known type of domed foot, seen in figure 152, which incorporates a groove around the top of the dome, in which candle grease would collect. The two specimens shown are of pewter, and it so happens that practically all existing examples of this type are of pewter; some of excellent quality alloy, but others have been found made in an exceedingly low grade alloy, little better than lead. The knop below the vertical socket on those shown here is an indeterminate shape, related closely to that on the pewter hexagonal based example on the left in figure 140, but on many others of this type it is a bold "inverted acorn". Sizes may range from about 4½ inches overall to 7½ inches; the latter with a base spread of 5 inches.

This is primarily a Spanish type, but it is considered that other countries, including the Netherlands, adopted the form, and it is to the more northern countries that one is inclined to attribute those of better quality. One example of this shape, intended to represent a silver specimen, is depicted in a painting by a Dutch artist, Hendrick Andriessen, shown here in figure 153. The artist was born in Antwerp in 1607, and died in Zeeland in 1655, and so we may be sure that the type had reached Holland before the middle of the 17th century. As the painting itself seems to make some topical reference to the fall of the monarchy in England in 1649, this may be taken as its approximate date.

The next illustration, figure 154, is of a pewter "drum-based" candlestick, hollow beneath the flat drip-catcher. Purchased in Spain, and believed to have originated there, it is of poor, leady metal, as are several other examples of the same form known to the writer. The type has some individuality in the shape of the plain socket, which tapers outwards more than most. A date of c.1730 would seem to be appropriate.

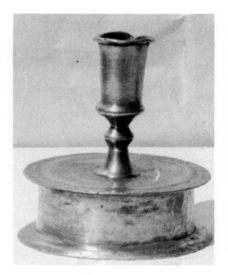

Figure 154.

11

William III to the Middle of the 18th Century

In Chapter Nine we left the flared-base candlesticks at a stage where they were beginning to absorb un-English features such as had been in vogue in Holland, Germany and France, in particular, for at least a decade. In the 17th century English candlesticks had maintained a decidedly national character within the two or three basic forms which have been dealt with in Chapters Six to Nine. These radical changes coincided with the coronation of William III, or followed it closely, and there is no doubt that the installation of a Dutch monarch and, doubtless, the importation of foreign craftsmen, were primarily responsible for the introduction of fashions and features, common on the Continent, but hitherto resisted by the conservative English brassworkers.

We have already noticed the decline of the octagonal base and the deletion of the pronounced drip-catcher in the pewter specimens of the period c.1685-90; and in figures 119, 138 and 139 we see the first indications of the tendency to adopt Continental fashions.

Figure 155 shows three brass candlesticks of varying forms; none fitting closely into an evolutionary pattern, but each, nevertheless, showing features which either have been observed in former types, or are likely to be seen in some of those which follow. The first and second items have the heavy balustered columns which were adopted in almost this exact form on both English and Irish silver candlesticks of c.1689-1710, and which were copied by the pewterers for a short period.

The sockets, too, are very much heavier, and with bolder ring mouldings than had formerly been seen, but which also were to be incorporated in future types. The third item in figure 155 has a slimmer column, but shows the nucleus of the low, completely square base which, for a short while, adorned other Dutch specimens in brass, such as those in figure 156; a difference in the latter, however, is that the corners of the square have been "lopped off", and a slight depression is appearing around the base for the collection of wax overflow; this becomes a little more pronounced in even later examples.

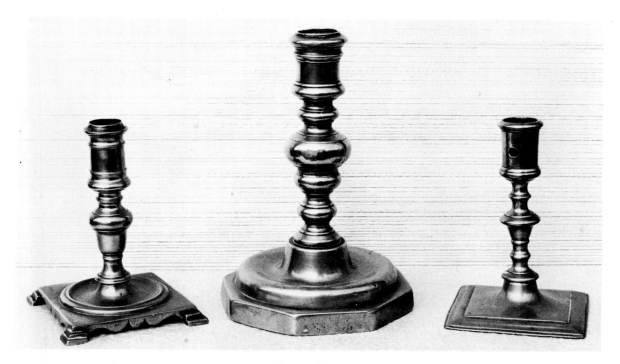

Figure 155.

It is significant that brass specimens still retain two lateral apertures in the socket, a continuance of the feature employed in other early to mid-17th century examples. These apertures, when found in the square-based baluster-stemmed candlesticks are sometimes the main indication of manufacture around the turn of the century, for we find that early 18th century specimens, especially after c.1710, although of very similar character in other respects, do not have them, nor do they

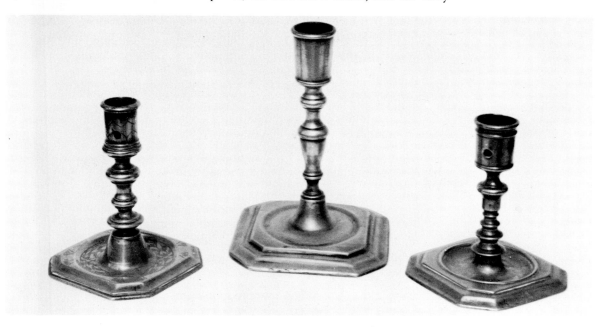

Figure 156.

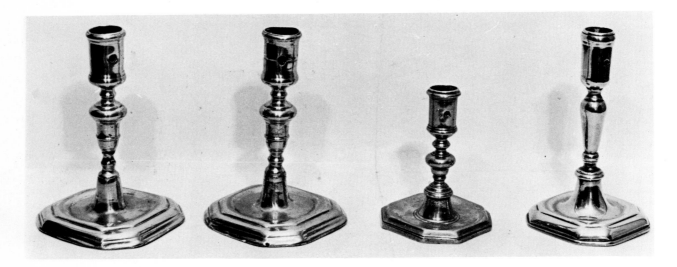

Figure 157.

appear in any later types. It is doubtful if the inclusion of lateral apertures can be used as any real guide to nationality, since they appear on many known Dutch and French brass 'sticks of up to c.1715; they do not, however, ever appear on English pewter candlesticks after 1710.

In figure 157 we find the square base with a slightly deeper moulding at the edge, and this continues into all later specimens until the base itself changes completely in character at about the end of the first quarter of the 18th century.

In figure 158 the pair on the outside show a rare form more French in character than English and one not very long lived. The form of knop is similar to those on the left of figure 157 and can perhaps be dated to the turn of the century or even perhaps a little later. The example in the centre is interesting because it moves towards the form of knop found in the three examples in figure 161 and which subsequently becomes flatter and less pronounced.

Figure 158.

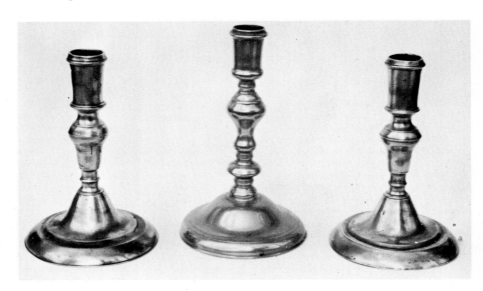

It was in the first few years of the 18th century that a major technical breakthrough was achieved. A method of casting the column in two halves was devised, the two halves being fused together down their length in a very accurate manner, and the "seams" being finally trimmed on a lathe to eradicate any trace of the join. The process is stated to be as follows:— "Brass filings and caustic soda (or other powdered chemicals) were placed on the flat surfaces at the edges of the two half sections, which were then heated until the filings melted. The two sections were then clamped together, and adhered as though they had been welded; this early method was known as 'sweating'." In many early 18th century candlesticks up to about 1760, the seam may be observed quite clearly (as in figure 164), especially when the metal is slightly oxidised. Similarly, if one breathes upon the column the seam will show up clearly. A column built on this principle had, perforce, to be fixed to the base in a different manner.

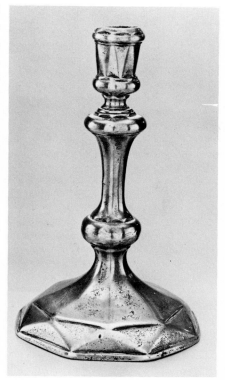

Figure 159.

Formerly a solid column was either screwed into the foot, or was riveted over beneath the base, to enable it to hold firmly; in the new process the "tang" of metal at the base of the column was rarely solid (when so, of course, the riveting method was continued), but now the portion which entered the foot was hollow, and a satisfactory join was accomplished by the use of a conical punch which expanded the outer edges of the tang until it fitted securely. Only rarely was the tang brazed to the foot. In later examples, an even simpler fixture was achieved by making several small cuts around the edge of the hollow "tang"; after insertion in the base these separate small flanges were spread outwards and then burred over by hammering. This process seems to be used even on modern examples.

This hollow column, by virtue of an unobstructed channel running through from beneath the foot to the inside of the socket, made the introduction of the next improvement a simple matter; this was the candle-stump ejector, in the form of a thin rod of iron running the full length of the column, and extending for about an inch below the hole in the base. At the top of the rod, within the socket, a small, flat, circular "button" of metal was fixed, and a similar flat button was attached to the lower end; thus the rod could be pushed upwards to perform its function of clearing the molten wax or stump from the socket, and then be pulled downwards again to a resting position, leaving the socket unobstructed. This feature was introduced about 1720, and its use continued, in the majority of examples, and in many countries, for about the next hundred years.

In figure 164 we can see a small hole in the middle knop where polishing has worn through at the point of the join which can be clearly seen below it. Figure 160 on the other hand has the thin features of the solid column and the clumsy join where the column meets the base. Figure 161 shows three seamed candlesticks, the one on the left hand side, though much worn from constant cleaning, still shows signs of a simplified form of the counter arranged triangular facets exhibited by figures 159 and 160. The second one is little larger than a taper stick being just over 5ins. in height. That on the right hand side has a hexagonal base stem and socket whereas the first two have octagonal

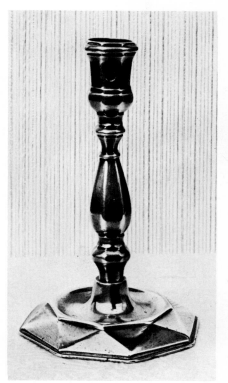

Figure 160.

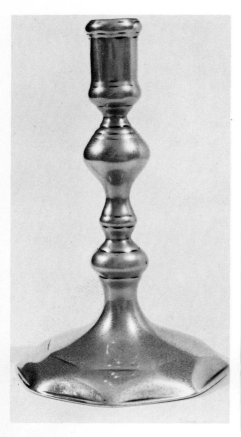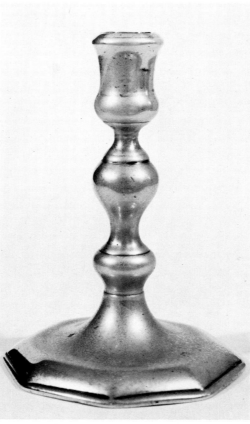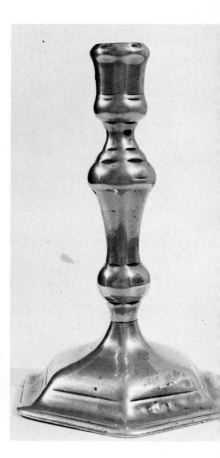

Figure 161.

bases and round stems and sockets, it is also of slightly later date and represents a move towards the square base featured in figure 163. All three are of a good golden colour. The middle example comes close to a Queen Anne silver design which would suggest a date around 1710-15, whereas figure 159 appears in silver about 1713 and as it did not continue in fashion for more than a few years a date of c.1720 might be appropriate. The third example in figure 161 has a raised base similar to the foot of a design for drinking glasses of the period. The stem is broader, the stick is bolder in appearance than the other two in the illustration but cannot be much different in date.

The main stream of development from figure 157 is shown in figure 162 a pewter example, in which the 'chamfered' corners of the square bases become slightly incurved. In silver candlesticks this feature appears about 1718-20. At the same time an entirely new shape of column was introduced, also copied from the silversmiths, and this too may be seen in figure 162. What had formerly been a large slightly flattened circular knop below the socket is now ridged below the top curve (see first and last examples in figure 163) and this "mushroom shaped" top to the knop appears on most examples up to at least the middle of the 18th

Figure 162 (detail).

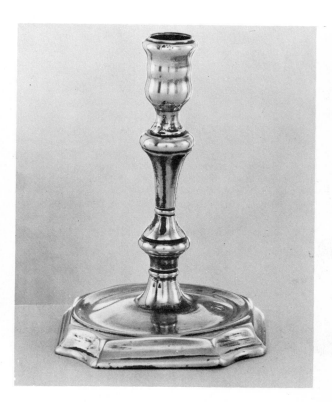

Figure 162.

century. The move from a rounded knop to a flatter "squeezed shape" knop seems to arrive only slightly before the sconce starts to reappear in general some time after 1720.

In the foregoing examples, particularly in the period c.1710 to 1720, it is noticeable that the sockets have taken on entirely new forms, some incurved at the sides with heavy ring mouldings at top and bottom, others incurved and flared outwards at the top, and with the latter has appeared a wider top flange.

In the majority of specimens this wide flange is cast as an integral part of the socket, but occasionally the flange is omitted in the original casting as the paktong example in figure 171, and a quite separate flanged insert is provided. This differs from those used in the 17th century in that the lower end of the section to be inserted in the socket is left open, to allow the use of the ejector rod. It would seem that a wide socket flange was not always a popular feature, for some makers made the same model both with and without flanges.

In figure 165 we see the first tendency to adopt bases of a more decorated form; up to about 1730 the squared base had held sway, with only few exceptions, but from c.1730 onwards many ornamental shapes were incorporated, so varied that it would be almost an impossibility to find two pairs of identical form.

The two pairs of candlesticks seen in figure 166, and the two singles in figure 167 are examples of c.1735-40 in which the "tang" of the columns is still solid, and since these also have a flatter base than those which follow, it is a reasonable assumption that the shallow foot is another datable feature. All examples which follow have a still more ornate foot, the edge of which is slightly skirted, and this is in

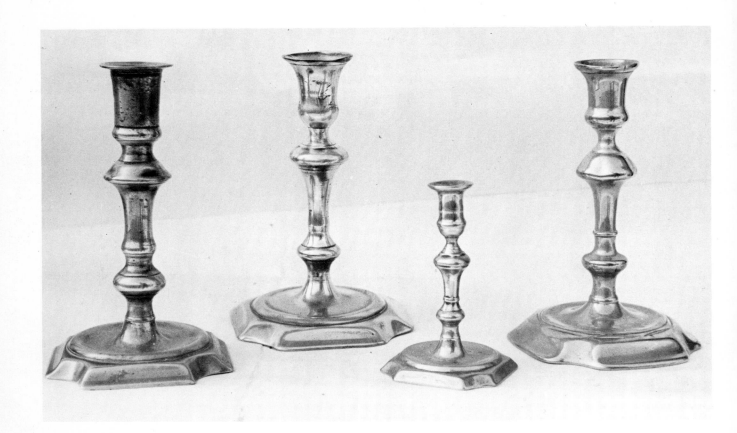

Figure 163.

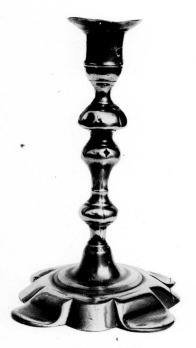

Figure 164.

conjunction with the movable "push-rod" ejector.

In figure 168 it is possible to demonstrate the practice referred to earlier, for here we have an obvious pair, so far as the foot, column and socket shapes are concerned, both of which have the hollow seamed column fitted with "push-rod" ejector, but whereas one has a wide socket flange cast integrally, the other has no flange around the top and, thus, it is apparent that the mould could be adapted to produce either. With the first example a separate sconce could have been used, or, perhaps, the customer preferred none at all. The bringing together of this "pair" was a major coincidence, for they were bought as single items, one in London and the other on the Sussex coast, with an interval of some twenty years between the two purchases.

A notable feature of the first candlestick in figure 168 is that it is one of the very rare examples bearing a maker's mark E^5K below the foot (shown in inset); this mark appears to be *incised,* i.e. in depth, below the surface, and thus must have been raised in the mould itself, an unusual occurrence.

This candlestick may be dated c.1750-55, and we should normally have had to accept this as the accredited working period of the maker "E.K.", but, by a happy coincidence, we find these identical initials (incorporated with a figure 1 at the top) in this instance impressed on the underside of both examples in another pair of very much later date (see figure 180). The latter pair is unlikely to have been made prior to

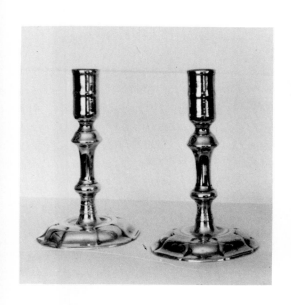

Figure 165.

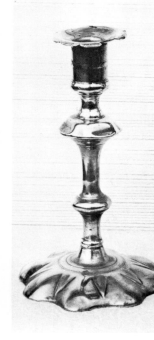

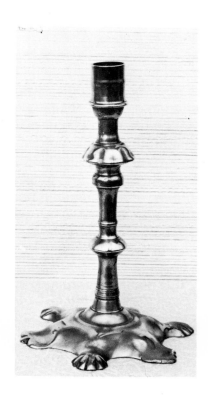

Figure 167.

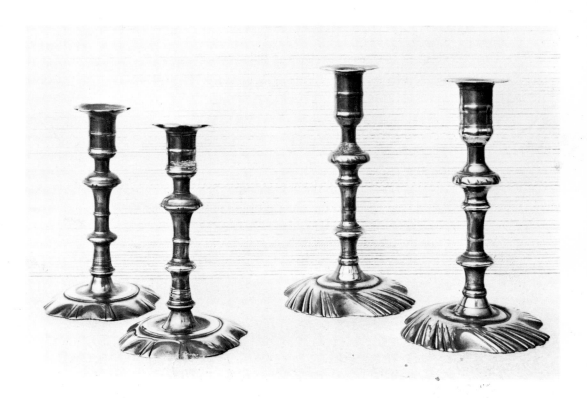

Figure 166.

Figure 168 (detail).

Figure 168.

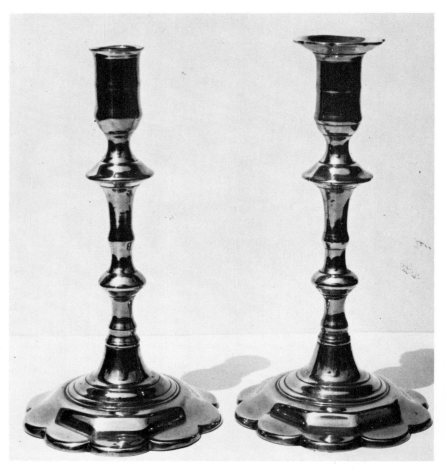

c.1775, and it is probable that it dates nearer to c.1785, so we can now assume a working period of some twenty-five or thirty years for the maker.

The figures (5 in the case of the earlier pair, and 1 in the later examples) would appear to have some reference to *type* but it seems somewhat anomalous that the examples which we should reasonably assume date some twenty-five years later should bear the earlier pattern number; perhaps it is some relationship to a dating code known only to the maker.

No name can be given to a maker with initials "E.K.", nor his location, but we are fortunate that two other makers did use their names in full on candlesticks of this general character, in the period c.1735-60, to wit, GEORGE GROVE and JOSEPH WOOD, although we do not know, even in those cases, where they worked. There are, so far as can be ascertained, no records in the archives of the Brassfounders' Company relating to actual makers, and the only hope will be to find a trade advertisement in some contemporary journal or directory.

Neither braziers nor brassfounders seem to have marked many of their wares, but there is a record of a printed document of 1780, signed by nineteen members of the Birmingham trade, announcing a rise of seven and a half per cent "in consequence of the late advance in the price of

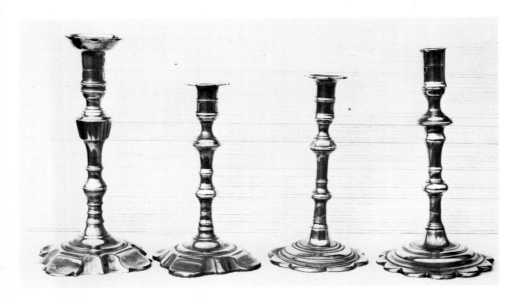

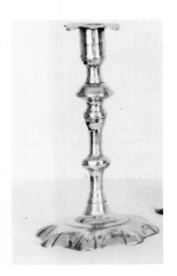

Figure 169.

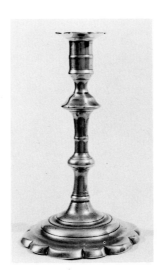

ingot brass". These names are appended hereto, but, of course, we have no information as to whether they ever made candlesticks; the names are as follows:- ATKINS & LONGMORE; JOHN BARKER; RICHARD BEACH; BOOLE & BARBER; GREW & SHERIFF; WILLIAM LOWE; SAMUEL PARKER; CHARLES POWER; PRICE PRITCHIT; JOHN ROTTON; JOHN SIMMONS; THOMAS SMITH; TIMOTHY SMITH; SMITH, COCKS & TAYLOR; TOWNSHEND & LONGMORE; THOMAS UNDERHILL; RICHARD WEBSTER; WILLIAM WHEELWRIGHT, and WHITWORTH & YATES. Many other names of brassworkers may be found in directories throughout the 18th century, and they, too, are of limited interest unless we know what class of wares they produced.

In figure 169 we show a representative group of the types of candlesticks in fashion up to c.1750, not only in England, but in most northern European countries; it would be a difficult task to attempt to assign any particular item to a specific locality. Only one feature seems to stand out as significant of French specimens, and this is

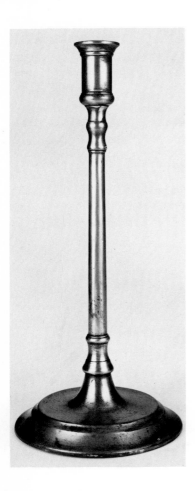

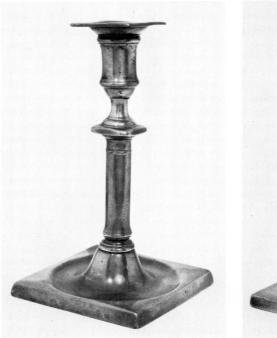

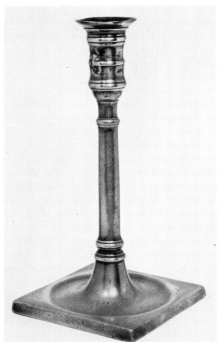

Figure 170.

the deeply cupped socket flange, as seen in the first example in figure 169; it is not claimed that this is conclusive, but only that it has been found more frequently on what are believed to be French specimens than on others.

Up to the middle of the 18th century it has been patently apparent that the silversmiths had inspired the brassworkers in many of their forms, but nevertheless the brass specimens have a certain *naiveté* of their own. About 1745, however, the silversmiths produced some far more sophisticated styles which were, perhaps, too costly for the brassworkers to copy. Specimens are found in base metal, nevertheless, but of an alloy known as paktong, which, it is believed, was used solely as a substitute for silver, and by the silversmiths themselves; they will, however, be given a chapter to themselves.

We cannot leave the first half of the 18th century without reference to a none too prolific group of candlesticks, which, in several respects, are reversions to styles in vogue some centuries earlier. Three representative examples are shown in figure 170. The long, plain stem is reminiscent of those in Chapter Four; the square base, with its shallow drip-catcher around the centre is more likely to be seen on specimens of the William III period, and the shallow circular foot of the first item is a close likeness to that on some 13th century candlesticks and is also a close analogy with figures 38 and 39, except that here the columns are completely cylindrical and do not display the entases apparent with earlier examples. The continued use of such early features shows clearly how the brassworkers (perhaps those in the provinces rather than the towns) clung to tradition and were reluctant to accept new standards. The only concessions they have made to fashion is the incorporation of the "push-rod" ejector in the second and third examples and a hollow, vertically sealed column in the first. These three examples, and most others of this general character, can be dated in the first quarter of the 18th century.

12

The Silver Forms in Paktong

About 1745-50, new, and distinctly ornate, styles were produced by the silversmiths, and, in silver, became exceedingly popular; they were, however, rarely copied in brass by English brassfounders. They were, nevertheless, made in another base metal, known as paktong, and, it is believed, by the silversmiths themselves.

Paktong, which is an exceedingly pale yellowish alloy, primarily of copper and zinc, was first produced by the Chinese, and was exported to Europe in the late 16th and early 17th centuries; it was, however, not used in any known commercial way until about the middle of the 18th century in England.

It is believed that some use was made of it in isolated centres elsewhere from a slightly earlier date; French makers made extensive use of it, and some fine Continental candlesticks in this metal may be found.

This pale coloured alloy is a composition of copper and zinc, with small proportions of nickel and iron (and, perhaps, some accidental traces of lead and cobalt). The paktong alloy is very hard and tough, and is not easily corroded; it is these qualities which have been instrumental in the preservation of the existing specimens. They are seldom, if ever, found dented, bent, scratched or damaged in any way.

When freshly cleaned with metal polish, or by buffing, this alloy is so "white" in colour that it is hardly distinguishable from silver, but after a few weeks' exposure to the atmosphere it will take on a pale yellowish discoloration, and will, in extreme cases, acquire an unsightly, decidedly greenish-tinged oxidation on the surface; this, however, is easily removed by cleaning.

The uses to which paktong was put, in England, were very much restricted, and seem to have been mainly confined to the making of candlesticks, candle-snuffers, fire-grates and the handles of fire-tools, and some smaller items, such as tobacco-stoppers and drawer-handles.

Candlesticks in paktong seldom, if ever, bear makers' marks of any kind, or any mark resembling one; on the other hand, German silver (nickel) candlesticks of the mid-19th century, for which they might otherwise be mistaken, are nearly all marked in imitation of English silver, including a semblance of a date-letter and assay mark, together

with some such emblem as a thistle, *fleur-de-lis,* crown, etc.; any article so marked is not likely to be of paktong. Another feature which classifies paktong is that the underside or inside of the candlestick bases are always smooth, the roughness of the casting having been chiselled or scraped away, as are the bases of cast silver candlesticks, whereas those in German silver, of some seventy or eighty years later, were usually left rough-cast, in the state in which they left the moulds.

The Chinese name for zinc imported into Europe from the early 17th century was *Tutenag,* and this name came to be applied, erroneously, to the Oriental alloy of copper and zinc.

Confusion arose, and was perpetuated by numerous writers, from the earliest times, and a variety of spellings for the word were adopted — Tutenac, Tutenage, Tutanag, Toothenague, and even "Tooth and Egg", being only a few. One writer has, however, gone to some trouble to clarify and explain the true origin of the words Tutenag and Paktong, and students can do no better than to refer to Alfred Bonnin's rare book *Tutenag and Paktong,* from which I have drawn freely.

Paktong is the Cantonese pronunciation of the Chinese word *pai-t'ung,* meaning white copper, and the term is now applied to any yellow or whitish alloy of copper, with nickel and tin, or zinc. Variant spellings of this word, too, have been noticed, such as Packtong, Petong, Pehtung and *Packfong*; the latter being a scribal error which originated with the Swedish chemist Gustave v. Engestrom, in 1776, and his erroneous spelling was adopted by many of the subsequent writers who quoted from his works.

With only one or two notable exceptions, candlesticks made in this metal can be dated to within a few years of their manufacture from

Figure 171.

118

comparable silver types. One of the exceptions referred to above is a pair, now in the Victoria and Albert Museum, from the Croft-Lyons collection, one of which is illustrated in figure 171a, which, from their form, appear to date around 1725-30, but as it does not seem likely that the silversmiths or the brassworkers would have produced such an early form as late as 1745-50, they must be presumed to be experimental examples, made some twenty years earlier, in the alloy that was certainly known about at that time, but which had not then been imported or produced in sufficient quantities to make its use a commercial success. Another notable exception must be the pair referred to towards the end of this chapter.

The superb pair of paktong candlesticks shown in Fig. 171 are of c.1750-55; the quality of workmanship in the finishing process is so high, and the method adopted in scouring the undersides of the bases is so exactly like that used on silver examples, that it is almost certain that these paktong examples were made by silversmiths. Two pairs, in silver, in these exact models are known, one by William Gould, of 1741, and the other by William Cape, of 1744. Careful examination shows that these columns have been cast in two vertical sections, later fused together, in exactly the same way as their silver prototypes.

The imported paktong alloy was said to be made from a secret formula, and no success has since been achieved, even after analysis, in producing an exactly similar alloy in Europe, and it would seem, also, that, after only a few years of commercial use, the secret was lost, for this high-grade enduring alloy does not, except in isolated instances, seem to have been used by metal workers after about 1775. An indication that the paktong alloy was too precious to be wasted is to be noted in the

Figure 171a.

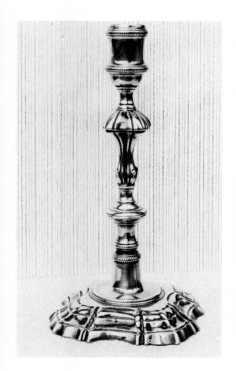

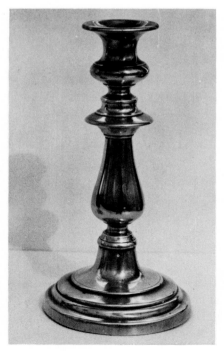

Figure 172.

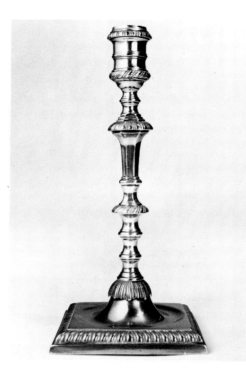
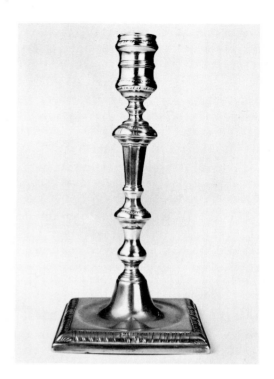

Figure 173.

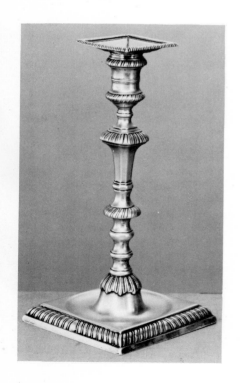

Figure 174.

fact that, although the ornamental top flanges of the loose sconces (of those in Fig. 171) are of paktong, the cylindrical tubes below are of pure yellow brass; no doubt, as this would not show when the sconces were in position in the holders, it was deemed unnecessary to make them of the rarer metal.

The first item in Fig. 172 illustrates another specimen of a closely similar type, but not of such pure "white" colour. It is, in all other respects, made and finished in exactly the same way as the former pieces, and since it is of very hard, exceedingly pale golden colour, quite distinct from true brass, it is believed to be cast from an experimental batch of alloy which seems to fall somewhere between the two. The second item is an exceptionally late example in experimental paktong, and is referred to later in this chapter.

Our next two examples (Fig. 173) are not a pair, although closely similar one to the other; for the first we have an exact counterpart in silver, shown in Fig. 174, made by Ebenezer Coker, London, in 1762. Of the two in paktong, one is very slightly less "white" than the other, and it seems obvious that great difficulty was experienced in attaining exactly the right mixture of ingredients.

Enough has already been said to indicate that, as a general rule, candlesticks in paktong could be expected to fall in the period c.1750 to c.1775; there will, however, always arise "the exceptions to disprove the rule" (and, thus, emphasise the unwisdom of ever putting into print unequivocal statements without qualification!).

The writer has seen just such an anomaly, i.e. a pair of true, pale paktong candlesticks of a form which cannot have been produced much earlier than the last decade of the 18th century. They were of superb

quality, solidly constructed, without any traces of vertical seaming, and were fitted with conventional "push-rod" ejectors, just as were brass examples of this date. One noticeable feature is that the hollow columns were brazed to the bases, whereas those of brass were more likely to have been affixed by a spreading out of the cut edges of the circular section and riveted over by hammering. One other example, (the second item in Fig. 172) is of a yellow coloured alloy (certainly not true brass) but of approximately the same late date as the pair just mentioned. This illustration shows what are believed to be, perhaps, the earliest and latest examples of attempts by European metalworkers to simulate paktong; the second item was, perhaps, produced by the brassworkers themselves, for this type seems to be too clumsy to have been inspired by the silversmiths.

For the final illustration here, Fig. 175, we show a pair of tall and sedate candlesticks; without doubt of about the mid-18th century, but lacking the refinements of the paktong and silver examples, and, in this case, made in a soft textured, deep coppery bronze. This is one of the rare instances of the production of silver forms by the brassworkers themselves.

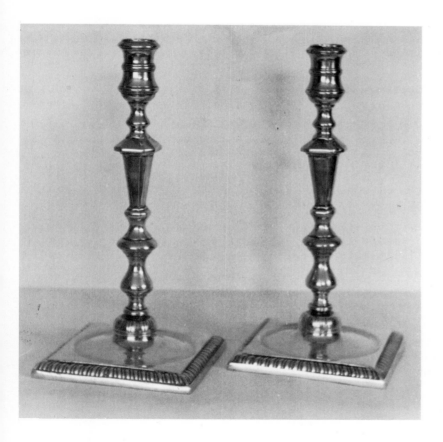

Figure 175.

13

George III and Regency Periods, c.1760-c.1820

With the reign of George III came significant changes in general style — from the "mushroom" knopped column to one which took on a neo-classical form; candle sockets departed from the conventional straight, or incurved, styles which had been almost a regular feature since c.1700, and displayed a multiplicity of shapes designed to suit the more stylised columns. In these sockets, too, the wide sconce-flanges were almost invariably cast as part of the candle-socket itself, and were not removable.

The Adam brothers undoubtedly had a great influence upon all fields of art, including, of course, both the silversmiths and the brassworkers, and the features of almost any mid to late Georgian candlestick column may be traced in contemporary furniture or architecture. The first indications, perhaps, may be seen in the examples on the left of Fig. 176; here the same square bases which had adorned some silver and paktong candlesticks of c.1755-60 are used again, but we now have a fluted, tapering, neo-classical column ascending to an urn-shaped socket with a wide flange top. The heavily fluted column first appeared in silver about 1775, but remained in vogue for a short while only; whilst still in favour, however, it was incorporated with a circular foot with a decided conical rise in the centre. The fluted column was only rarely accompanied by the still later "incurved pyramidal" base, which became a feature of several of the succeeding types (figure 177). In the meantime, the column lost its flutes, and by 1785 the plain, tapering column had become a firm favourite (figures 178 and 179).

Contemporary with the popular classical tapered column, we find the plain cylindrical stem, also set upon the "incurved pyramidal" base, but used far less prolifically.

Figure 180 shows this adequately; the tall pair, of c.1775 or thereabouts, lightly corrugated (although very worn) for about two inches at the lower end before it enters the foot, has a very restricted socket, formed by a simple expansion of the diameter of the column. The columns are vertically seamed, and contain the "push-rod" ejector, and the socket flanges are cast integrally. It is this pair to which a brief reference was made on page 112 and each of which bears the maker's mark E[1] K.

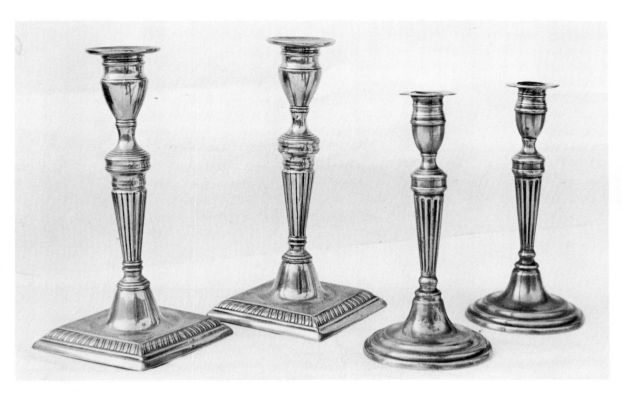

Figure 176.

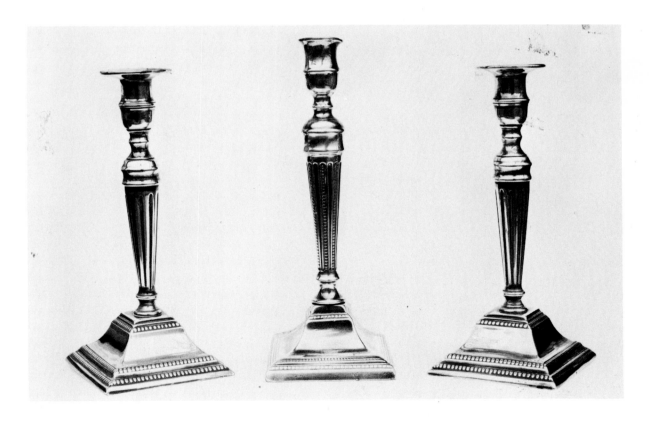

Figure 177.

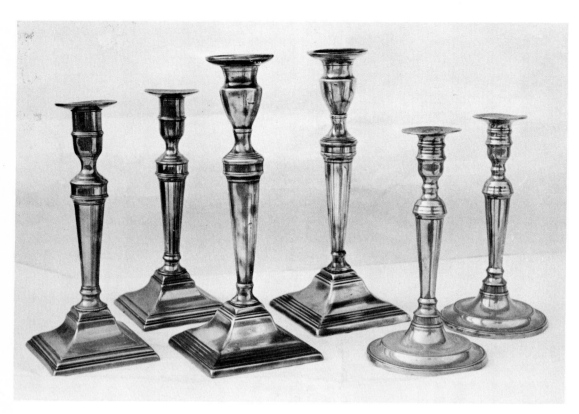

Figure 178.

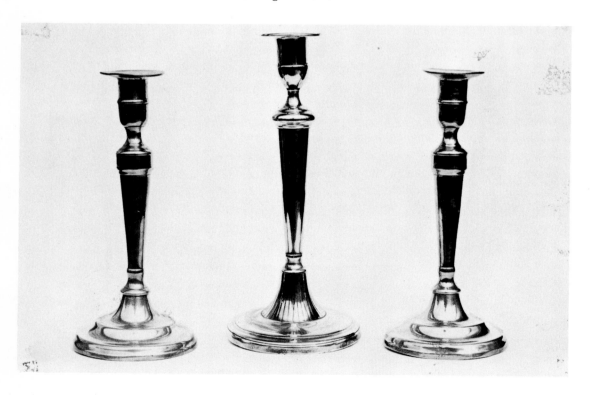

Figure 179.

The "beaded" mouldings which adorn the bases of the specimens in figures 177 and 180 may generally be considered a somewhat earlier feature than the completely unadorned pyramidal foot, but not, perhaps, exclusively so, for, although there is little doubt that those mentioned above ante-date the plain foot by about ten years, in isolated instances (such as on the squat specimen in figure 180), it persists into examples which one would be reluctant to date earlier than c.1790-1800. Whilst this particular example is under consideration, it is pertinent to mention that on a pair of very closely similar, squat examples (but with plain pyramidal base) a maker's mark of a large capital letter H has been found cast in relief on one of the four facets beneath the base — again, unfortunately, giving no indication of the name of the actual maker, or of his provenance.

In the group in figure 181 we have various baluster-knopped columns with "tulip-" or "urn-" shaped sockets, and also, in two of them (one in brass and one in pewter) for the first time, an incurved, conical oval foot; this latter seems to have been used sparingly between c.1780 and 1800, and turns up later in only isolated instances.

From here on the brassfounders again took command of candlestick fashions, and we find a multiplicity of forms which had not previously appeared in a rarer metal. They mostly display complicated baluster and knop combinations, some variations contrived by the reversal of a portion, or of the whole, of the column. The method of attaching the hollow column to the foot was by spreading the hollow "tang" after insertion in the foot, until it became a tight fit in the hole provided for it.

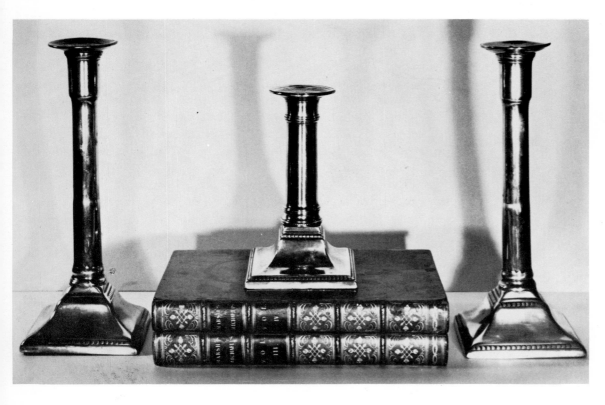

Figure 180.

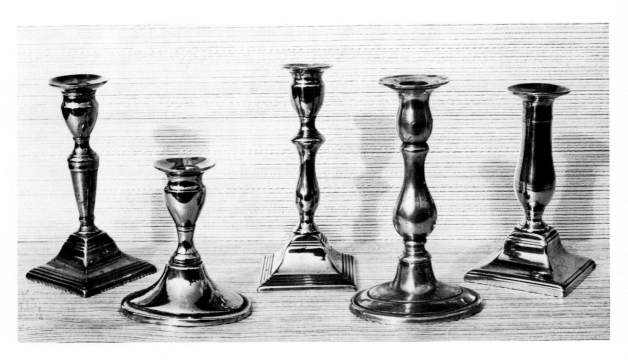

Figure 181.

In practically all examples the push-rod ejector is incorporated. As a general rule, the late Georgian examples (figures 182, 183) were made of a slightly softer, more malleable alloy, of a good rich golden colour, and tended to be finished with more care; seldom, if ever, was the underside of the base left untrimmed, and consequently, size for size, in comparison with 19th century specimens in figures 184 and 185, they were much lighter in weight. Changes in style of column and foot were now so frequent that it is a virtual impossibility to date them chronologically; as many as twenty different forms might appear in a ten-year period. One noticeable characteristic of candlesticks made after c.1820 is a certain lack of individuality of form; the square, or octagonal base, is of slightly less overall diameter, and the underside of the bases is quite often left untrimmed; push-rods are found far less frequently than on 18th century examples, and, most noticeable of all, the alloy is now a decidedly yellow, hard and brittle zinc brass, with little, if any, lead used to soften the colour and texture.

In the last quarter of the 18th century a large variety of baluster column candlesticks, in a hard, pewter-like alloy, began to appear, differing greatly in actual quality of alloy, and also in form, from any pewter examples we have already noted. It is possible that the alloy was made hard by the inclusion of either bismuth or antimony, perhaps both, and it may be that zinc, too, was added. The resultant alloy had a slightly "bluish" tinge when highly polished.

When these are discovered today, they are frequently found to have acquired a hard, dark and ugly, oxide, or "scale", which cannot be cleaned off by normal polishing or scouring, and which has to be removed by chemical action. When clean and bright, however, they retain a high lustre for a much longer period than do those in the softer, more conventional pewter.

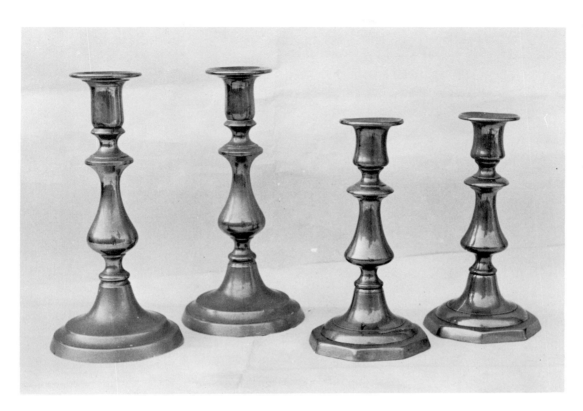

Figure 182.

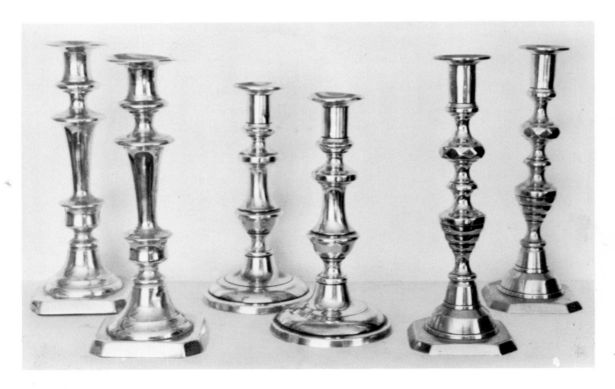

Figure 183.

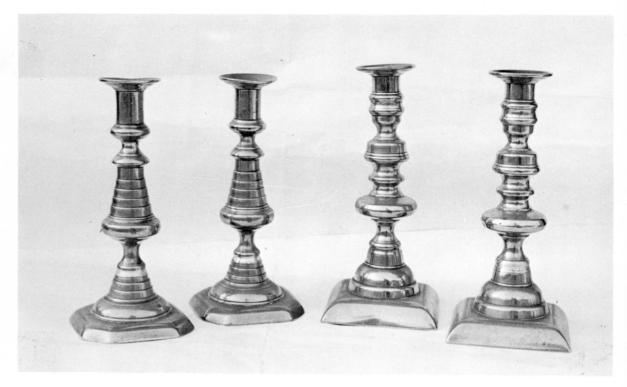

Figure 185.

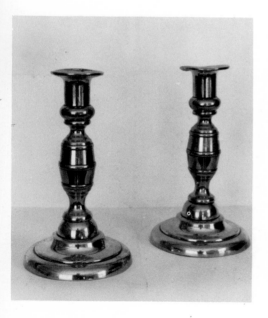

Figure 184.

Naturally enough, these pewter candlesticks followed the current fashions, so far as shape and style are concerned, and they almost invariably include the push-rod ejector described earlier. The group of pewter candlesticks in figure 186 are representative of the many hundreds of differing mouldings, and in shapes alone, many are indistinguishable from brass. Those in figure 182 are of brass, and it will be seen that these and the pewter examples have a similar circular foot and the wide sconce-flange. In all the foregoing, both pewter and brass, this is an integral part of the top casting, but in a few others, of pewter, this wide, saucer-shaped flange is found to be quite separate and removable; this is a "throwback" to the mid-18th century practice we have seen used on brass and paktong specimens in c.1750-65.

All the candlesticks we have illustrated so far in this chapter, are believed to be English, but there cannot be real certainty of origin in all cases, because of the almost universal use of some of these late forms. If one were to select one or two late 18th century national characteristics to be used as general guides, these would be (a) for France, the deeply cupped socket-flange, to which attention has already been drawn, and a high, stepped, moulded foot on both brass and pewter specimens; (b) for Germany, Austria, Switzerland and Scandinavia, a rococo, wrythen (sometimes upright) fluting on base and column, especially in pewter examples; (c) Sweden and Norway, fretted, and sometimes relief-cast, ornamentation around the skirt of the base, and sometimes, too, the

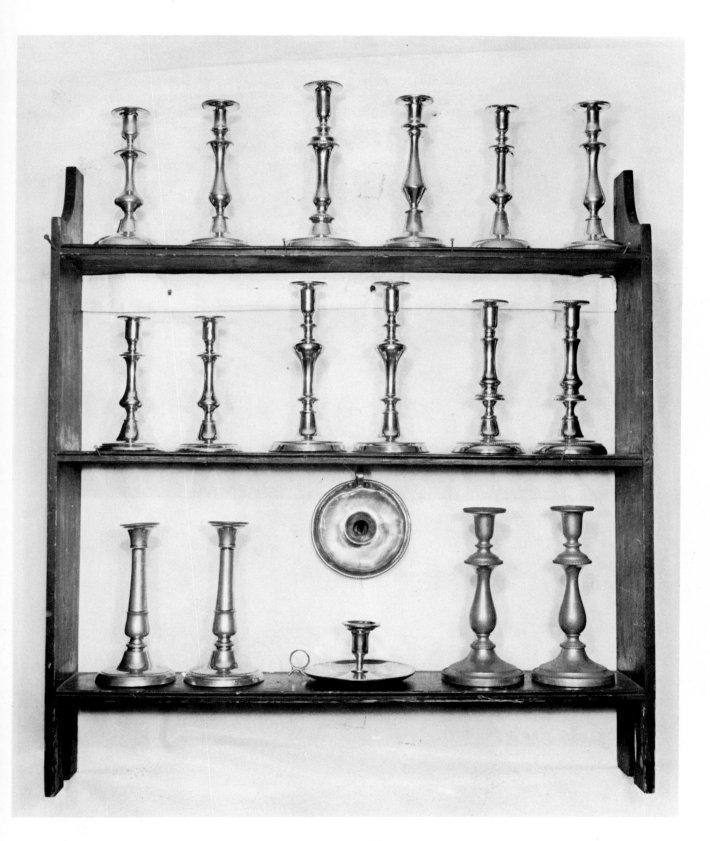

Figure 186.

addition of projecting feet; these are found more frequently on Scandinavian candlesticks at this time than on those of other nationalities. Swedish pewter candlesticks are likely to bear makers' marks.

There is one typically Spanish form, of which many examples have been found in recent years, and of which two representative specimens, (dating from c.1828-30) are shown in figure 187; the style seems to start from about the middle of the first quarter of the 19th century. They are made in a hard, yellow brass, in four sections, the majority held together by a long iron rod, or "tongue", extending from the top column, and passing through the separate drip-catcher, lower column and foot; this is held by a nut on the screw-thread at the end. The general character of these candlesticks is somewhat similar to the four-piece "Heemskerk" specimens, but the styles of sockets and baluster columns are obviously of much later date. All examples examined by the author have been tall, ranging from a height of about twelve inches to nineteen or twenty inches overall. Many are left rough-cast beneath the foot.

Figure 187.

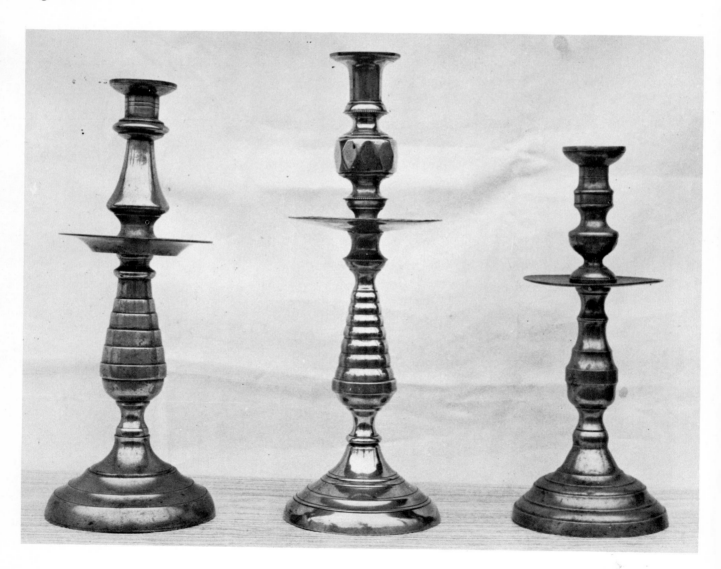

14

Candle-Stump Ejectors, Candle Savers, and Miscellaneous

Up to c.1700 the main means of clearing the candle sockets of molten wax or tallow was by gouging this out with the aid of some suitably pointed tool; no doubt, this was a difficult task with messy molten tallow, and so, in a great many instances, lateral apertures were provided through which this could be done more expeditiously. In the early 17th century another method was adopted, firstly by the pewterers, and had a popular, though somewhat limited following; this was the provision of the separate and removable socket-cup, which could be carried away into the kitchen to be cleared of surplus tallow. The use of separate sconces seems to have been discontinued by the pewterers by about 1675, but was resurrected, by the silversmiths, in particular, in the mid-18th century, but again soon dropped out of favour, to be brought back yet a third time (again by the pewterers) at the end of the century. No doubt it was found that these loose sconces tended to become lost on occasions, and so other devices and methods were sought. One of these was the "lateral slide" ejector; an early usage of which is to be seen on the pair of Cromwellian brass candlesticks c.1650 (figure 188). The slide ejector does not seem to have been put into general use until the first quarter of the 18th century, possibly because of the complexity of fitting and riveting the iron spring which held the slide firm at any required position in the opening in the column. In the reign of Queen Anne, however, and sporadically throughout the 18th century, we find the device used on quite a number of brass candlesticks. It is noticeable, in all cases, that the slot for the slide is made low in the stem, to allow a length of candle to be kept intact within the hollow column, only enough being brought up above the socket flange for immediate use; if more were exposed to the heat generated by the flame this would cause it to melt away more quickly. Although this slide device became increasingly popular, and was, in fact, used on some examples up to about 1825, it was, nevertheless, unable to withstand the competition of the "push-rod" ejector, which, as we know, was used to a far greater extent. In figures 189, 190 and 191, we show "slide ejector" candlesticks of Queen Anne and Georgian periods. The tall candlesticks in figure 192 are unusual in that the top of the long stem is cast from a mould, part of

Figure 188.

Figure 189.

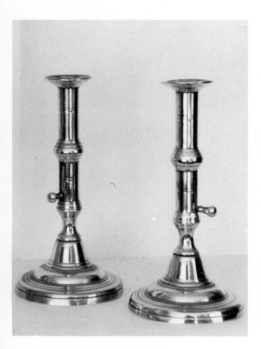

Figure 190.

which could have been used to make the complete column for the smaller specimens. Many tall examples are to be found in collections, but it is a regrettable fact that a large number of them are reproductions made, perhaps, only some fifty years ago or so, and artificially "aged". This particular pair is of the period c.1780-1800.

In figure 193 a variation of the slide ejector is shown, in which the candle is "stepped up" by lodging the slide in one or another of the four horizontal slots. Yet another method of candle adjustment is shown in the wrought iron candlestick in figure 194, in which the candle is raised merely by turning the loose candle holder to a higher position in the open spiral column; examples of this nature were made from early in the 18th century, but neither they, nor the tray-based chamber candlesticks really come within the limited scope of this volume, although, in many of the latter, the columns are of the identical form used on pillar candlesticks. One or two examples are shown, however (figures 195, 196) merely to indicate the general character in use over a very long period. In many cases a separate conical candle "douser" accompanies the tray-based examples, and is usually held by an angled bracket, the tip of which may be inserted in a hole prepared for it in the handle. In the more sophisticated examples, such as that in figure 197, the fretted base is deep and circular, made in this form to accommodate a cylindrical glass shade. With such a low candle socket it was sometimes necessary to be able to reach to a short stump of candle with the glass shade in position, and so a "douser" with a long shaft was needed. In the example shown this is held at the side.

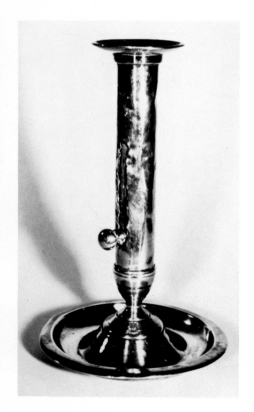

Figure 191.

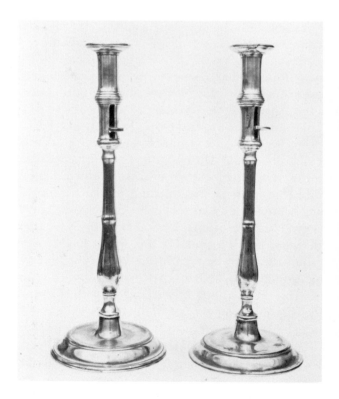

Figure 192.

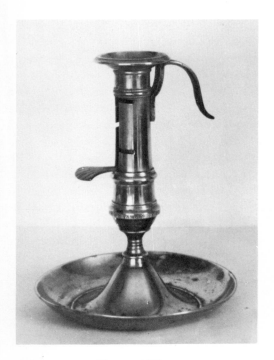

Figure 193.

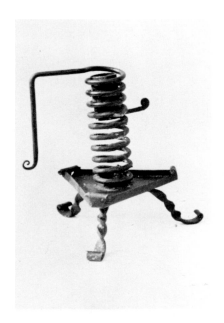

Figure 194.

Figure 195.

Figure 196.

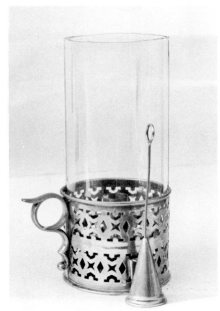

Figure 197.

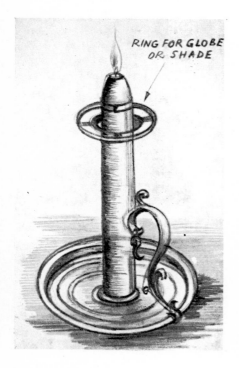

Figure 198.

For the remainder of this chapter it is proposed to show a few representative examples of the "oddities" and inventions of the 19th century, some of which were quite ingenious devices, and were patented by their makers, but of which none seem to have caught public fancy to any great extent; no doubt because we were now entering the age when coal gas was about to be made available to the town household, and for the homes without gas there were available some fine and decorative oil lamps with large ornamental fonts and shades.

Figure 198 shows an ornamental spring-loaded candlestick of c.1850; this is a patent of one William Palmer, of Bow Road, Middlesex, and was designed to burn a special type of "Magnum Candles", containing eight parts tallow, one part resin, and one part vegetable wax, and could be made with one, two, or three wicks. The candle is contained inside the hollow column, and is kept constantly tight against the top opening by a coiled spring inserted beneath the candle through a hole in the base; the ring near the top is intended to hold a globe or shade. Examples such as this were shown at the Great Exhibition at the Crystal Palace in 1851, and were marketed by Palmer & Co., Clerkenwell, London. They frequently bear a soldered-on brass label; this particular specimen has such a label, reading:- "PALMER & CO., Maker, LONDON — FOR THE METALLIC WICK CANDLES". Another spring-loaded type, which also allowed the candle to be contained in the stem, and only the wick to be visible, is the "CRAMPTON'S PATENT", shown in figure 199.

One device, by no means a useless oddity, was the coiled wax-taper holder, or "Wax Jack", as it came to be called. This seems to have been introduced in the mid-18th century, and the first appliances to hold such

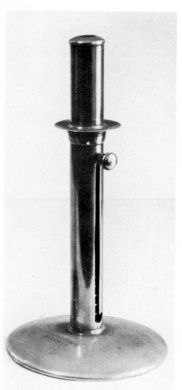

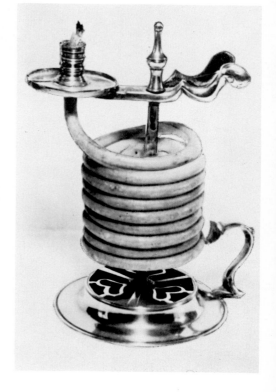

Figure 200.

Figure 199.

a taper were, no doubt, similar to that in figures 200 and 201. This particular example would have held a crudely made long taper which was coiled by hand around the long centre stem, one end of the taper being brought up to a position between the spring-operated jaws at top; when the short length of taper above the jaws burned down to the metal, the jaws snapped shut and doused the lighted wick, whilst to maintain a light it was necessary continually to increase the length above the jaws. In later examples, made to accommodate a pre-coiled taper, the spindle in the centre could be unscrewed, and a complete (coiled) taper dropped into position, and the spindle replaced. Taper holders of this character, some of particularly handsome design, were made in Sheffield Plate between the years c.1790-1820 and, in due course, they were copied by the brassworkers; brass examples are, however, comparatively rare. The specimen in figures 200 and 201, is of brass, and is shown both with and without the coiled taper. Figure 202 is another similar example in brass, complete with its snuffer. Examples of a very similar design still appear in trade catalogues c.1850.

Improvements of this coil-holder included the taper "drum-winder", in which a revolving cylinder held the pre-coiled taper, instead of it being placed in a fixed position. Taper boxes were also a popular item; in these a wax coil was enclosed in a circular box with lift-off lid, and with a carrying handle at the side, rather like a string box, a hole in the lid allowing a free end of the taper to protrude. On many of these devices there was a separate conical "douser" suspended from a ring by a short chain, long enough to reach the lighted taper, but these today are frequently missing.

Figure 202.

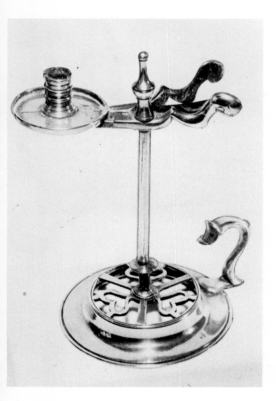

Figure 201.

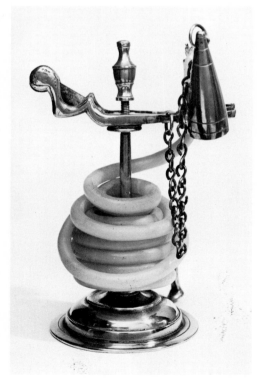

Appendix

CONSTITUENTS OF
BRASS/BRONZE AD 800-1840
(from Arnstein Berntsen's
Lys Og Lysstell, published by
Gyldendal Norsk Forlag,
Oslo, 1965)

☐ Lead

▥ Tin

◩ Zinc

■ Copper

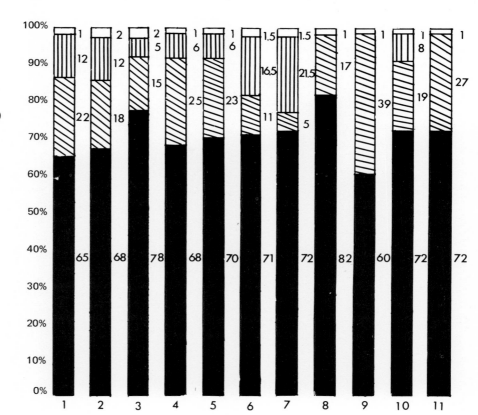

	Period	(Pb) % Lead	(Sn) % Tin	(Zn) % Zinc	(Cu) % Copper	Colour	Metal
1	800-1050	1	12	22	65	Reddish grey	Brass
2	1050-1300	2	12	18	68	Reddish grey	Brass
3	1300-1550	2	5	15	78	Greyish gold	Brass
4	1600-1650	1	6	25	68	Yellowish grey	Brass
5	1600-1650	1	6	23	70	Golden grey	Brass
6	1650-1730	1.5	16.5	11	71	Red gold	Bronze
7	1650-1730	1;5	21.5	5	72	Reddish grey	Bronze
8	1650-1730	1	0	17	82	Yellowish	Pure brass
9	1730-1790	1	0	39	60	Rich gold	Pure brass
10	1770-1810	1	8	19	72	Yellowish gold·	Brass
11	1800-1840	1	0	27	72	Rich golden yellow	Pure brass

Bibliography

BOOKS

Tutenag and Paktong, Alfred Bonnin, Oxford University Press, London, 1924.

Gammal Mässing, Sigurd Erikson, ICA förlaget, Västerås, Sweden, 1964.

Old Brass Candlesticks of English Make, W.G. Mackay Thomas.

The Gloucester Candlestick, Charles Oman, H.M.S.O., 1958 (V and A).

Koper en brons van voorheen, A.J.G. Verster, Amsterdam, 1966.

Antique Brass Candlesticks 1450-1750, John R. Grove, published privately, Maryland, U.S.A. 1967.

ARTICLES

Domestic Candlesticks from the 14th C to the end of the 18th C, Alexander O. Curle, F.S.A. Scot., *Proceedings of the Society of Antiquaries of Scotland,* 8 February 1926.

Taper Sticks (Wright Bemrose Collection), Chas. R. Beard, *Connoisseur,* November 1931.

Some Early Pewter Candlesticks, H.H. Cotterell, *Connoisseur,* February 1934.

Brass Candlesticks of Queen Anne's Reign, G.B. Hughes, *Country Life,* September 13, 1946.

The Earliest Pewter Candlestick, W.G. Mackay Thomas, *Antique Dealer and Collector's Guide,* June 1947.

Early English Candlesticks, W.G. Mackay Thomas, *Country Life,* August 22, 1947.

Altar Candlesticks, W.G. Mackay Thomas, *Antique Dealer and Collector's Guide,* June 1948.

Some Anomalies of English Candlesticks, W.G. Mackay Thomas, *Apollo,* July 1951.

Early Dutch Pewter (Heemskerk Candlesticks), R.M. Vetter, *Apollo,* May 1951.

Candles and Candle Fittings, R.W. Symonds, *Antique Collector,* February 1952.

English Domestic Brassware, G.B. Hughes, *Country Life,* April 11, 1952.

Old English Candlesticks, Part I, G.B. Hughes, *Apollo,* February 1953.

Old English Candlesticks, Part II, G.B. Hughes, *Apollo,* April 1953.

Silver Taper-sticks, G.B. Hughes, *Country Life,* April 26, 1956.

17th Century Pewter Candlesticks, A.V. Sutherland-Graeme, *Connoisseur,* April 1956.

Candlesticks in Silver, Edward Wenham, *Antique Collector,* June 1956.

Wax Taper Winders and Holders, G.B. Hughes, *Country Life,* November 22, 1956.

Beautiful Brass, Cyril G. Bunt, *Antique Dealer and Collector's Guide,* June 1957.

Fine British Pewter in American Collections (pr. pewter candlesticks by Hugh Quick 1675/80), *Apollo,* January 1960.

English Silver Candlesticks, Y.A. Fulwell, *Antique Collector,* December 1966.